IMAGES
of America

FOREST PARK HIGHLANDS

The best school picnics ever! merry Christmas! Love, Ron & Kathy 2007

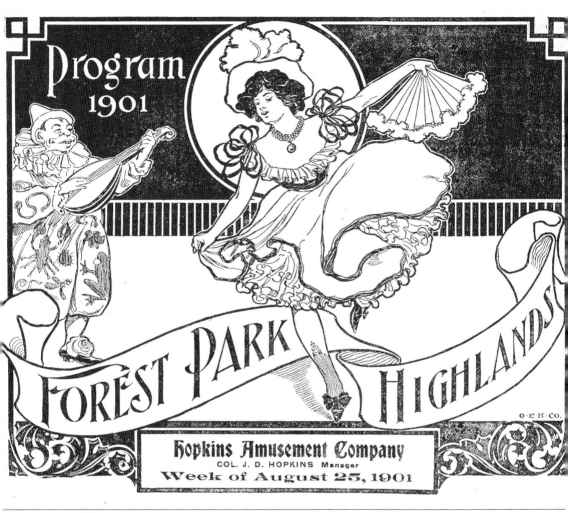

This 1902 advertisement lets people know what kind of entertainment to expect. Comedy, as shown by the clown, and the dancing girl with lots of petticoats showing is telling people that no boring or deep presentations will be on this stage. It is strictly fun tonight, with cancan dancing at Forest Park Highlands.

On the cover: A young mother helps pilot her two children on the Highlands's boat ride. After the Hall of Laughter was closed due to rising insurance costs, the large building was remolded and used for the location of several rides over the years. The Enchanted Forest, the Boats, a Cuddle Up, and finally the Bubble Bounce found a home in this large building located just behind the park's swimming pool. (Courtesy of the Western Historical Manuscript Collection, University of Missouri–St. Louis.)

IMAGES

of America

FOREST PARK HIGHLANDS

Doug Garner

ARCADIA
PUBLISHING

Published by Arcadia Publishing
Charleston SC, Chicago IL, Portsmouth NH, San Francisco CA

Printed in the United States of America

Library of Congress Catalog Card Number: 2007931941

For all general information contact Arcadia Publishing at:
Telephone 843-853-2070
Fax 843-853-0044
E-mail sales@arcadiapublishing.com
For customer service and orders:
Toll-Free 1-888-313-2665

Visit us on the Internet at www.arcadiapublishing.com

To the people of St. Louis

CONTENTS

ACKNOWLEDGMENTS

The first person I would like to thank for helping me get this book published is my editor Anna Wilson and Arcadia Publishing. Arcadia took a chance with my book when no one else would. Don Lewis Sr. and Don Lewis Jr., former employees of Forest Park Highlands, were invaluable with the amazing photographs they sent, along with wonderful stories about working at the Highlands. Rose Kennedy, also a former employee, was a great help.

Tom Haller deserves a hearty thank-you for introducing me to the Dogtown Historical Society, including Bob Corbett and Sally Yamamoto, where I was able to obtain a lot of valuable history, as well as make a lot of new friends.

Ken Rutherford, thanks so much for the photographs of the Comet's unique cars. Scott Rutherford (no relation to Ken), thank you for the blueprints.

My best friend Charlie and my clientele deserve credit for putting up ad nauseum with my incessant talking about the Highlands and St. Louis. My next door neighbor Michelle deserves thanks for that too. My good friend Bill Cordes, thank you. Foster Church, thank you for helping with integrity issues.

A thank-you has to go out to my partner, Hastings Wyman, for the technical help.

The most important thank-you of course goes to my late parents, who would drive me by the Highlands, Westlake, or any of the other St. Louis amusement parks just to keep me quiet and content.

Thanks so much to everyone who has read my Web site on Forest Park Highlands and who sent me photographs, information, and stories. Many anecdotes they shared with me appear throughout the text. If you have more you would like to share, or if you want to tell me how you liked the book, I can be reached at FPHDoug@aol.com.

I couldn't have made this book possible without any of you.

INTRODUCTION

The year 1896 saw the first year of life for St. Louis's largest amusement park, Forest Park Highlands. Anton Stouver had purchased the property from two brothers known today only as the Rice brothers.

The Rice brothers had tried to make a better business of their Highlands Cottage restaurant by adding a steam driven carousel. They were surprised to find more people came to ride the carousel than to eat at the restaurant.

Stouver bought the property, added one of the longest scenic railways, a Traver Circle Swing, and Forest Park Highlands was born.

An early entrance building was constructed facing northwest, directly in line with the 1904 St. Louis World's Fair. The park added a beer garden, and top name entertainment—the best that vaudeville had to offer—soon appeared in the park's theater.

Many romances were started and probably finished in the park's second-story dance hall, above the main restaurant on the first floor.

New rides were brought in year after year. As soon as the 1904 St. Louis World's Fair closed, several attractions were brought over for a second life at Forest Park Highlands across the street. A large pagoda that had served as an entrance to the amusement section at the fair became the new entrance for Forest Park Highlands. The top 165 feet of an electrical tower was also brought over and used as the base for an illuminated American flag.

During the early 1920s, Forest Park Highlands installed one of the largest swimming pools in the nation.

Roller coasters have always been the lifeblood of an amusement park, and Forest Park Highlands was no exception. Early on the park boasted two roller coasters, the scenic railway near the front of the park and an early version of a Loop-the-Loop coaster. A few years later, after the scenic railway and the Loop-the-Loop were dismantled, a large side-friction coaster was built along Oakland Avenue near the front of the park. A faux mountain facade was built covering the structure. It was known as the Mountain Ride, an early predecessor to Disney's Space Mountain. The facade was later removed. Then another coaster, a twin-track racing coaster known as the Derby Racer or Racing Derby, was built towards the east end of the park.

In 1934, the owners built a ride that made Forest Park Highlands a rarity among American amusement parks. The Flying Turns, or Bobsleds, was constructed on the former site of the Mountain Ride. The Flying Turns was designed by Norman Bartlett, who built only eight of these rides throughout the United States. It was a free-wheeling ride in a barrel structure,

which simulated a bobsled run commencing up the lift hill in an enclosed dark tunnel. In 1941, the park built the Comet on the site of the Racing Derby.

Working at Forest Park Highlands became a career for many people instead of just another summertime job. Entire families would work here for most of their lives.

This all came to a spectacular end on July 19, 1963, when a small fire started in the basement of the park's restaurant. The conflagration soon became a five-alarm, out-of-control fire. The blaze spread west, turning the dance hall building and restaurant into a heap of ashes in a matter of minutes.

Then the fire turned right, devouring the covered picnic area once known as the Tanbark Trail. Soon flames engulfed the entrance rotunda, a six-story structure serving as the entrance and housing the offices. As the front of the building collapsed, thousands of sparks flew into the air, melting the pavement on Oakland Avenue and signaling the end of a well-loved St. Louis landmark.

Forest Park Highlands was not the only amusement park in St. Louis. A mile west on Oakland Avenue, where McClauslin Road intersects with Oakland, was the site of an earlier, smaller amusement park known as West End Heights. It only lasted a few years but had an early racing coaster, a Ferris wheel, and a theater.

Suburban Gardens, an early park containing a scenic railway and other attractions of the time, was located off Highland Street.

Delmar Gardens was one of the fanciest amusement parks in the area, with more than one roller coaster. It closed down in the 1930s.

Westlake Park on Old Rock Road and Natural Bridge lasted until May 19, 1955, when a fire destroyed most of the park.

Chain of Rocks was nestled on top of a bluff overlooking the Mississippi River. Its near-hidden location gave it the aura of a magical place.

Holiday Hill, on the corner of Brown Road and Natural Bridge Road was a well-known kiddie park. A large Renaissance Hotel is on the site today.

This book will bring back many fond memories for people in St. Louis, educate younger readers about some of the wonderful places that were part of St. Louis history, and inform all of us about some of the nation's once-grand amusement parks that are no longer with us.

One

THE EARLY YEARS

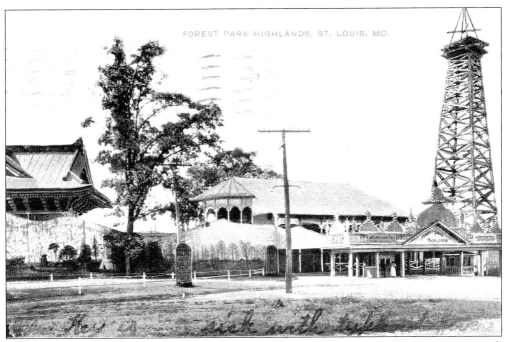

FOREST PARK HIGHLANDS, ST. LOUIS, MO.

The first entrance to the Highlands was a flimsy affair, not becoming to a new amusement park at all. It faced northwest directly in line of the 1904 St. Louis World's Fair across the street in Forest Park. A more substantial building would be constructed in 1912. This postcard view shows, from left to right, the pagoda bandstand, the scenic railway, and a wood tower that would be replaced with a newer 140-foot steel version, complete with an American flag on top.

The old Johnson estate was turned into the Highlands Cottage Restaurant by a pair known only as the Rice brothers. They soon added a steam-driven carousel. When business failed after only a year or two, the property was handed back over to the owners, the Stouver family. Soon other rides and attractions were added. Forest Park Highlands was born. As shown in this postcard view, the midway was made up mostly of games and exhibits.

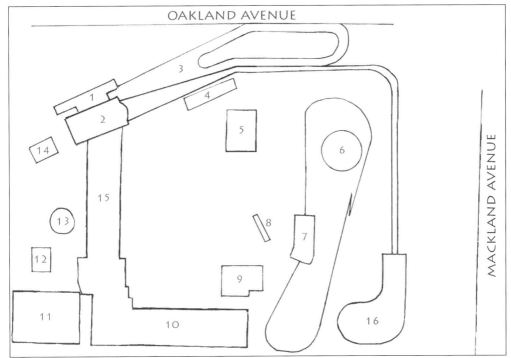

OAKLAND AVENUE

MACKLAND AVENUE

The Highlands of 1903 was quite a bit different than in later years, but that was true of any amusement park in the early 20th century. The guide to this map is as follows: entrance to the Highlands (1), scenic railway (2), Pony Track (3), bowling alley (4), Cottage Restaurant (5), merry-go-round (6), Loop-the-Loop (7), Ferris wheel (8), pool and billiards (9), dance hall (10), theater (11), Cave of the Winds (12), photo studio (13), 108-foot-high wood tower (14), midway beer garden (15), and scenic building (16).

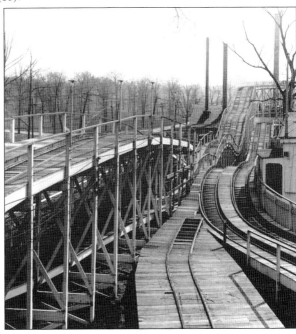

The L. A. Thompson Scenic Railway was billed as "the longest ride in the world." The ride's beginning started on the second floor of a two-story building directly behind the entrance. This view shows the start of the ride as well as the first half that paralleled Oakland Avenue, heading east. The chimneys in the background are the Highlands Brickworks, situated immediately east of the park. (Courtesy of Missouri Historical Society, St. Louis.)

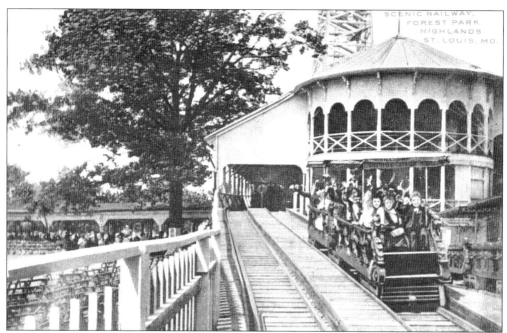

The scenic railway at Forest Park Highlands lived up to its claim as being the longest in its day. The track was over a half-mile long. It started at the front of the park, traveled east along Oakland Avenue, turning south before the brickworks next door. The ride entered a scenic building that was changed from year to year. It then turned around forming a J shape where the Comet would later stand. Each set of cars had its own brakeman controlling the speed.

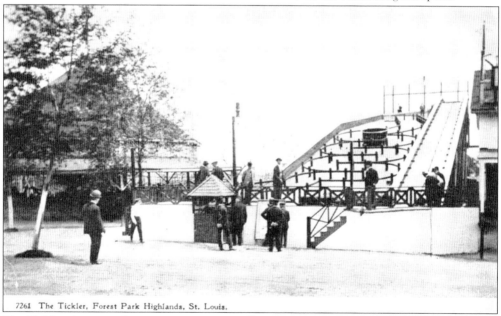

7261 The Tickler, Forest Park Highlands, St. Louis.

The Tickler, shown in this view, was in practically every amusement park in the early part of the 1900s. The Highlands's version was situated between the carousel and the dance hall. The ride was considered to be the precursor of a later ride called the Virginia Reel. Highlands's Tickler was replaced by a shooting gallery by the 1920s.

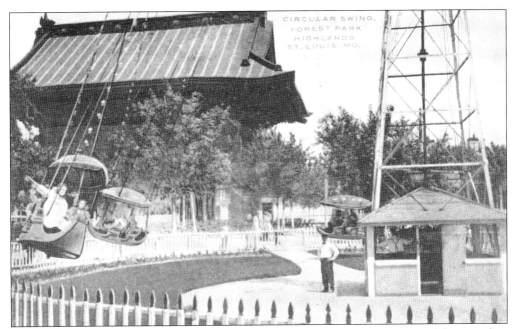

In the early 1900s, all rides like the one shown here started out with ornate gondolas complete with fringe. The technical name was the Circle Swing. In the early 1920s, most of the gondolas were replaced by biplanes of some sort. In the early 1940s, to give a modernistic Buck Rodgers look, the biplanes were replaced by large silver jets complete with red fins.

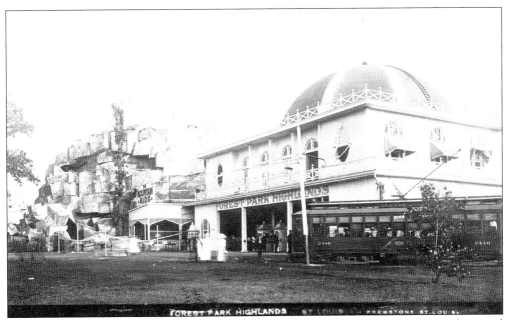

The year 1912 brought about big changes for Forest Park Highlands. A much more substantial and attractive entry building was built. The top half of this building would be remodeled several times over the Highlands's lifespan while the bottom section would remain essentially the same. The old scenic railway was replaced by a larger more modern roller coaster named the Mountain Ride.

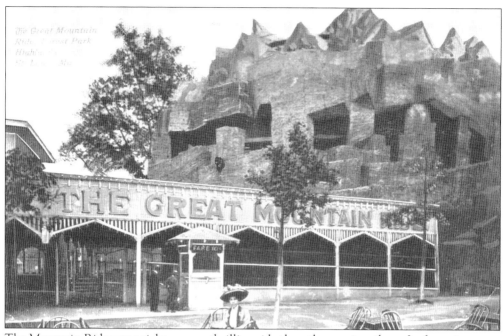

The Mountain Ride was a tighter more thrilling ride than the scenic railway. Its footprint was a figure eight, crossing under and over itself several times. The ride was made all the more exciting by having the structure covered over in a faux mountain facade which would later be removed, leaving the wood support timbers exposed.

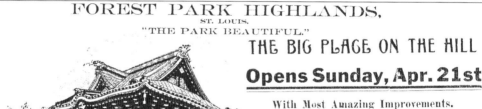

FOREST PARK HIGHLANDS,
ST. LOUIS.
"THE PARK BEAUTIFUL."

THE BIG PLACE ON THE HILL

Opens Sunday, Apr. 21st

With Most Amazing Improvements.

····CONCERTS BY····

WEIL'S BAND

THE PEER OF THEM ALL.

THE NEW COTTAGE

Finest Open-Air Restaurant west of New York.
High-Class Kitchen.
JOE EHRMAN, Manager.

And the Latest Amusement Devices that can be
seen in no other Garden.

HANDSOMEST BAND STAND IN THE WORLD. AN EXACT REPRO-
DUCTION OF THE GATEWAY TO THE TEMPLE OF NEKKO, JAPAN, **ONLY PARK CHARGING ADMISSION**
COSTING $30,000. FIVE THOUSAND ELECTRIC LIGHTS.

Advertising cards, as shown here, were a popular way to give notice of a park's new attraction. There usually would be a small illustration of the new ride or exhibit plus loads of information. Among other things, this card advertises the new restaurant and includes the manager's name, Joe Ehrman. The opening date of the park is also included. That year it was April 21.

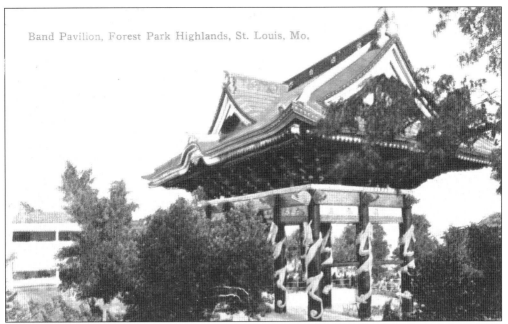

Band Pavilion, Forest Park Highlands, St. Louis, Mo.

When the 1904 St. Louis World's Fair closed a year later, many of its attractions were sold to the Highlands. One of the most striking was the Japanese pagoda that was used as the entrance to the Pike, or amusement area of the fair. The pagoda was advertised as "the handsomest bandstand in the world." It was an exact replica of the gateway to the temple of Nekko, Japan. The red and black structure complete with golden dragons crawling up the supports was bought for $30,000, a large amount of money for 1905. Over 5,000 electric lights were used. Famous bands of the era, such as the Weils Band, "the peer of them all," played there.

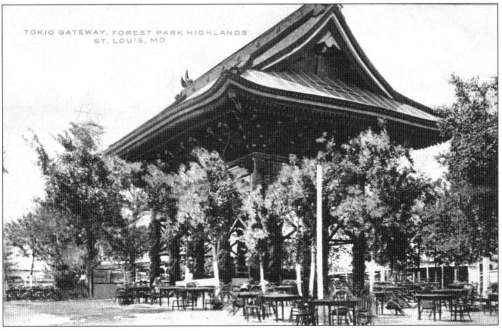

TOKIO GATEWAY, FOREST PARK HIGHLANDS
ST. LOUIS, MO.

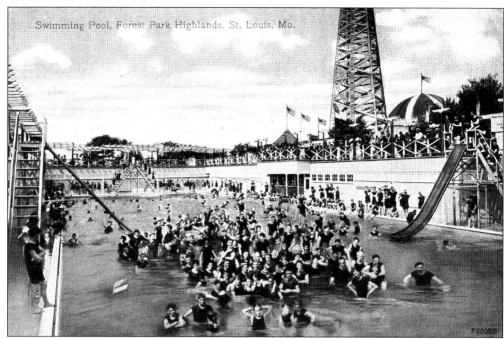

In 1913, Anton Stouver decided that to have a complete outdoor entertainment garden, he needed to add a public swimming pool, so he put in one of the largest pools in the Midwest. The pool formed a perfect western border in between the theater and Oakland Avenue. When the pool was first built, it was surrounded on three sides by dressing rooms, showers, and concessions. On the roof was a pool balcony. In later years, the dressing rooms, concessions, and showers were scaled down to just the north side of the pool. When the pool first opened, it also had slides starting from the balcony roof down to the surface of the water. The top view is looking north towards Oakland Avenue and the bottom is looking south at the old theater building.

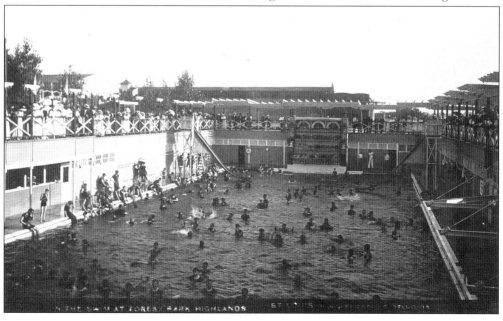

Two

THE GROWING YEARS

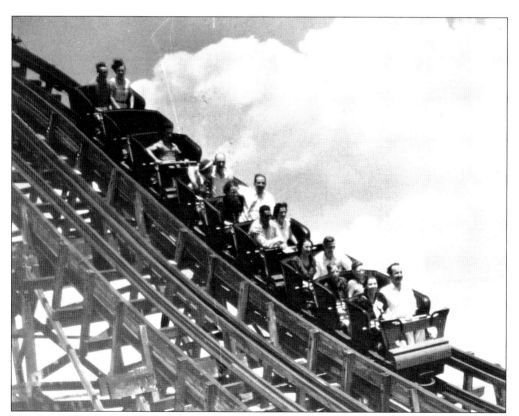

The Racing Derby was the fourth coaster in the Highlands's history. The twin-tracked ride was a misnomer. It was actually one very long single track that crossed over itself, appearing like a set of parallel tracks. This kind of roller coaster was called a continuous track racer. A rider would board on the right side of the boarding station, then after the ride was over, he or she would disembark on the opposite side of the station leaving more that one confused rider. (Courtesy of the Western Historical Manuscript Collection, University of Missouri–St. Louis.)

The 1920s brought several changes to the Highlands, enabling the park to compete with other major amusement parks in the city. The key to the map is as follows: domed entrance (1), pagoda bandstand (2), Mountain Ride (3), arcade (4), Dodgems (5), the old Highlands Hotel now used as offices (6), Racing Derby or Derby Racer (7), carousel (8), Century Flyer miniature railway (9), shooting gallery (10), airships (11), beer garden (12), dance hall/restaurant (13), Hall Of Laughter (14), Auto Race (15), 120-foot steel flag tower (16), swimming pool (17), and concessions (18).

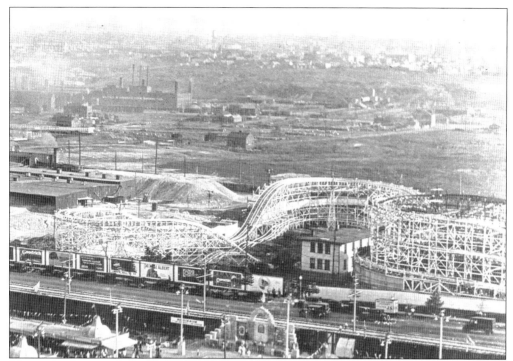

This early photograph shows three of the Highlands's early roller coasters. From left to right are the racing coaster; behind that, almost hidden, the racer's structure; the remains of the scenic railway's tunnels; and the Mountain Ride, sans its faux mountain facade. In the midst of the three coasters is the old hotel.

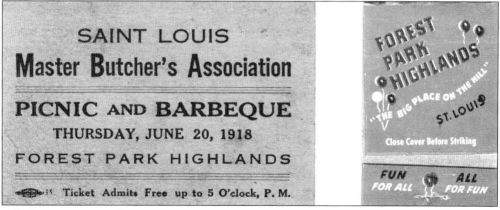

SAINT LOUIS
Master Butcher's Association

PICNIC AND BARBEQUE
THURSDAY, JUNE 20, 1918
FOREST PARK HIGHLANDS

35¢ Ticket Admits Free up to 5 O'clock, P. M.

FOREST PARK HIGHLANDS

"THE BIG PLACE ON THE HILL"

ST. LOUIS

Close Cover Before Striking

FUN FOR ALL ALL FOR FUN

Jeff of St. Louis remembers a park he never knew: "I'm a current resident of St. Louis and was not alive to have experienced the park. My parents, however, have told me many a wonderful tale from their many trips there! I've lived here for 16 years, and each time that I drive past Forest Park Community College, I wonder what it would be like if [the park was still open] today."

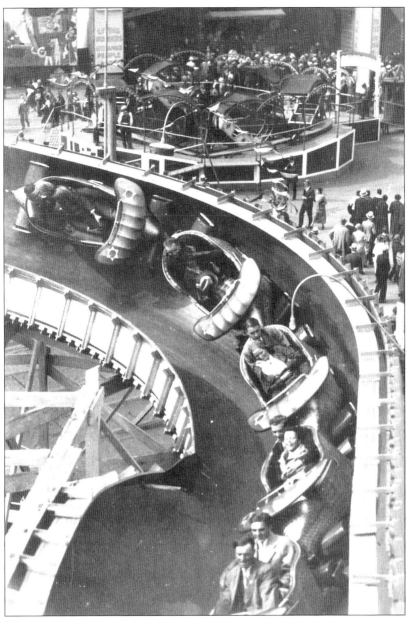

In 1933, Forest Park Highlands was due for refurbishment to bring the old park up to date. Nothing would do this better than a new roller coaster. Norman Bartlett had designed a new type of coaster that did not use the standard roller coaster track. The Flying Turns had cars that free-wheeled up and down the sides of a wooden trough, similar to a bobsled run. The cars had casters that rotated instead of stationary wheels. This allowed for freedom of movement with the sudden change in direction that rides called for. The troughs were lined in three layers of cypress wood similar to bowling allies. Soon the Mountain Ride was quickly torn down and the new Flying Turns replaced it, insuring the Highlands a special place in amusement park history. The Highlands's Flying Turns had a red-roofed tunnel covering the entire incline. As riders would leave the tunnel and enter the first helix, a load horn would go off. There were only seven different installations of these rides.

Sherri tells of this memory: "Having grown up in the St. Louis area, I have many fond memories of going to the Highlands as a youngster and being in total awe of the Comet structure. I never got up enough nerve to ride the Comet, but did go on the Bobsled [Flying Turns], with my dad, making sure that his arms stayed tightly around me as we flew through the tubes."

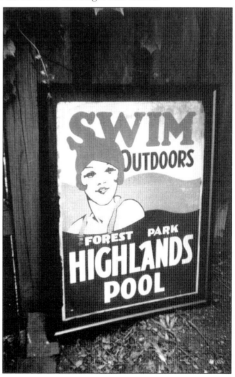

Karen of Clayton remembers, "In 1963, I was working at the corner of Vandeventer and Washington, when I heard the news on the radio and drove into Forest Park to watch the disaster. I guess I'm a big wuss . . . I remember going to the Highlands in the late 1950s, going up in the Ferris wheel and being so frightened, I screamed, I cried, and made the operator stop and let me off."

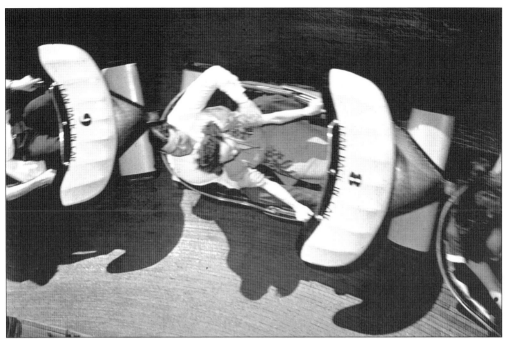

The Flying Turns careen over one of the many banked curves. The ride's circuit was shorter than most wood coasters, but these scrappy rides held their own against any other rides in the park. The cars shown in this photograph are the original ones. In the years to come, the cars would be replaced by a more modern art deco–style vehicle. (Courtesy of the Western Historical Manuscript Collection, University of Missouri–St. Louis.)

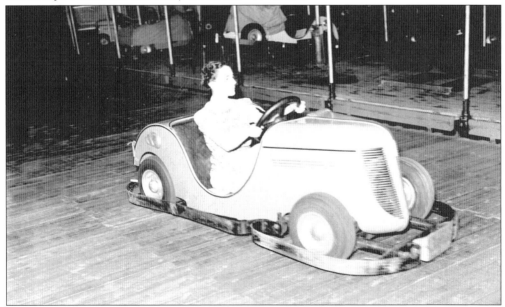

In this early photograph, a young lady takes a solitary drive on the park's Dodgem cars. There is no pole going up to the top to a mesh roof to conduct electricity. The extended bumpers made sure that the collisions were of a mild nature. The floor surface is a hardwood floor. (Courtesy of the Western Historical Manuscript Collection, University of Missouri–St. Louis.)

In this early postcard view, a group of well dressed, somber-looking gentlemen enjoy a day of fun and frivolity at Forest Park Highlands. The cutout of the automobile was used in the very early years of the Highlands. The postmark is dated 1907. Later a woman named Lida Platz operated the photo salon. The backdrops later became a crescent moon and a horse.

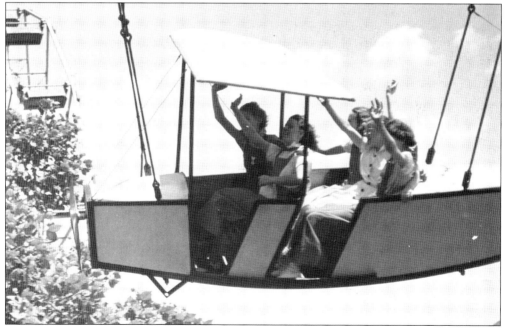

The airplane preparing to land here needs no Lambert Field. These five ladies try an age-old dare on the biplanes, riding "no-handed." The Circle Swing was designed by Harry Traver, who was also responsible for designing three of the most extreme roller coasters ever built. Today there is one Circle Swing awaiting refurbishment at a Pennsylvania amusement park.

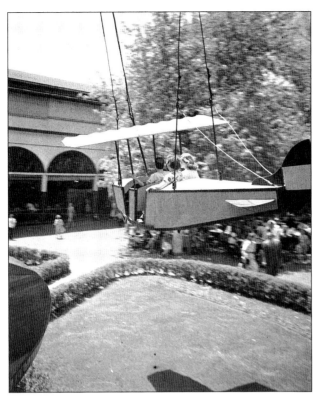

The biplanes have been added, as well as the newer elevated loading platform. The three people in this plane seem to be headed straight for the park's restaurant and dance hall. Fortunately, the little planes will turn just in time again and again. The Circle Swings, while a quiet ride, gave just enough thrill, as well as a scenic, circular view of the park. Every amusement park had one. The three main parks in St. Louis, Forest Park Highlands, Westlake, and Chain of Rocks, each had the ride. Suburban Gardens, one of the earliest St. Louis parks, had one. Now the only operating Circle Swing is a re-creation named the Golden Zephyr at California Adventure at the Disneyland Resort in California. (Courtesy of the Western Historical Manuscript Collection, University of Missouri–St. Louis.)

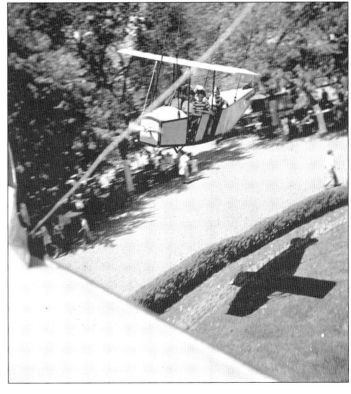

Three

THE GLORY YEARS

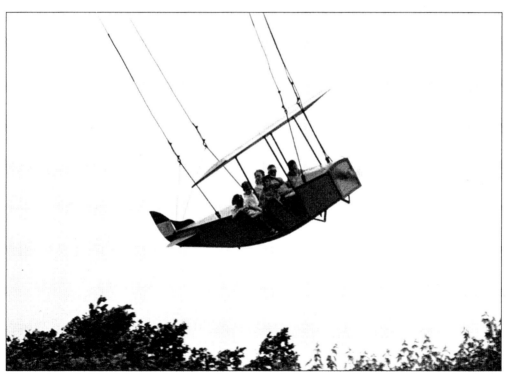

Flying along Oakland Avenue has never been so much fun, especially while riding in the planes found at the Highlands Airport. This group of women can attest to that. Once a staple at every amusement park, these rides are sorely missed by every ride connoisseur and amusement park fan out there. An offshoot of this ride are the smaller swings where the rider faces outward. (Courtesy of the Western Historical Manuscript Collection, University of Missouri–St. Louis.)

GRAND OPENING MAY 28th

Smooth Dance Club

FOREST PARK HIGHLANDS
BALLROOM

EVERY WEDNESDAY — 8:30 P.M. to 12 P.M.

ADMISSION..25c

PRESENT THIS CARD FOR FREE ADMISSION
FOR 2 TO PARK MAY 28th
DANCING NITELY

168

The dance hall was almost a separate entity from the amusement park. It opened later in the season and stayed opened later in the evenings. Sending out cards for "dance clubs" was a good publicity ploy to bring people into the park by way of the dance hall. In the late 1950s, the dance hall was boarded up and used mainly for storage, but it was quite the place in its day.

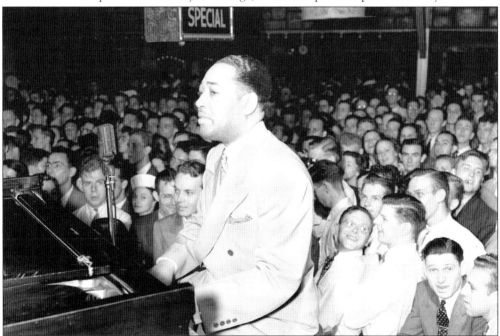

Duke Ellington packs them in at the Highlands. Crowds of up to 1,800 people would crowd in the dance hall. Sunday was the big band night. Celebrities like Ellington would draw in the crowds, insuring a good season for the park. The war years, with all the servicemen and women, also did a great job of guaranteeing success at St. Louis's most popular amusement park. (Courtesy of the Western Historical Manuscript Collection, University of Missouri–St. Louis.)

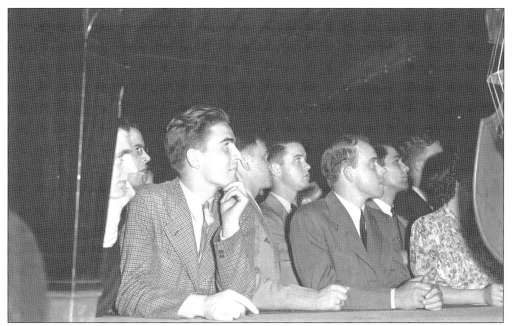

On a good night, business would begin as soon as the Highlands would turn on its 40,000 lights. Ties were required. Occasionally belts would be found in the hall. If someone was without a tie, they could rent a "tie belt" for only a quarter from the enterprising person watching the door. (Courtesy of the Western Historical Manuscript Collection, University of Missouri–St. Louis.)

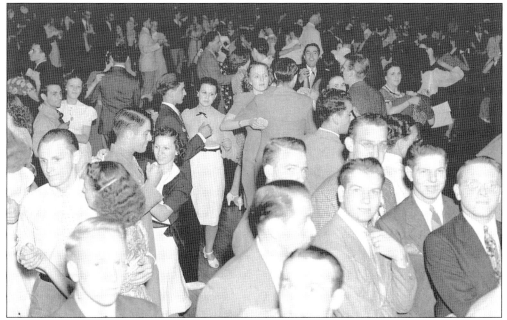

The dance hall was a massive building making up the entire south border of the amusement park. The north side of the hall was open so one could catch a nice St. Louis breeze and overlook the park. It was large enough to house full orchestras like the Dorsey's or Glenn Miller. On Sunday nights, if a popular band was playing, the crowd many times would swell from 12,000 to 20,000 people. (Courtesy of the Western Historical Manuscript Collection, University of Missouri–St. Louis.)

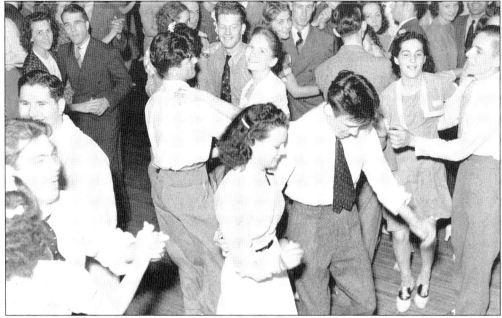

Spectators and saddle shoes were all the rage when this photograph was taken in 1946. The Jitterbug was the popular dance. The dance hall was in full tilt. A warm Saturday night would bring in as many as 6,000 visitors. Some came as couples; more often than not, several hoped to be couples by the end of the evening. (Courtesy of the Western Historical Manuscript Collection, University of Missouri–St. Louis.)

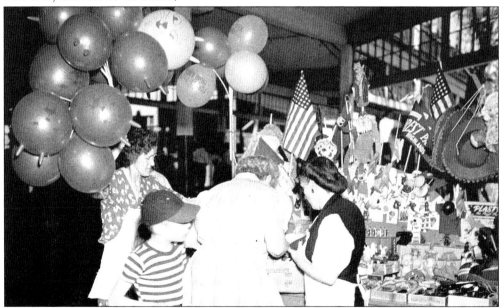

These three ladies restock the counters while a young boy checks out the merchandise. A small pocket knife with "The Highlands" on the leather cover could be one choice, as well as the numerous felt pennants, or an American flag. A balloon would be an inexpensive choice, but they seldom made it home intact. (Courtesy of the Western Historical Manuscript Collection, University of Missouri–St. Louis.)

Many of the rides in the park's Kiddieland were known as "umbrella rides," as most of them were under large umbrella-type canvas covers and traveled in a circular route. To the very young children, these rides were terrifying and exciting, until a few years later when their older siblings would sneak them on to the larger rides. (Courtesy of the Western Historical Manuscript Collection, University of Missouri–St. Louis.)

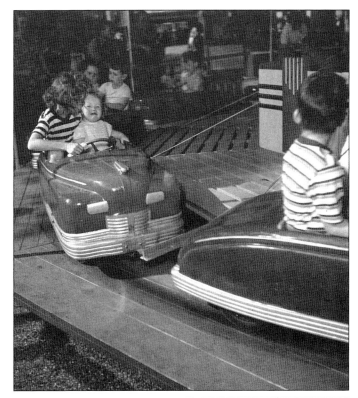

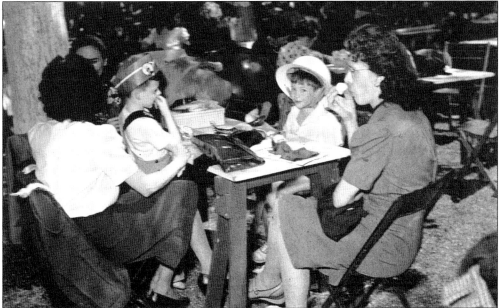

A day at the Highlands was not just to ride the Comet or the Bobsleds. It was a day to catch up on the local gossip under the parks many trees in the picnic grove. Meeting old friends and making new ones was a perfect way to spend time between rides or waiting for the husband to meet the family after work. (Courtesy of the Western Historical Manuscript Collection, University of Missouri–St. Louis.)

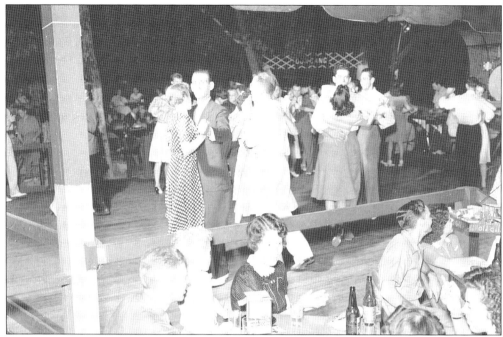

After the pagoda was removed, a modern dance shell was built. It too hosted bands, such as that of orchestra leader Harry Cage. Rainy nights, called "Jive Nights," were reserved for musicals. At 9:30 p.m., the crowds would stream out of the streetcars that made the loop in front of the Highlands's entrance. (Courtesy of the Western Historical Manuscript Collection, University of Missouri–St. Louis.)

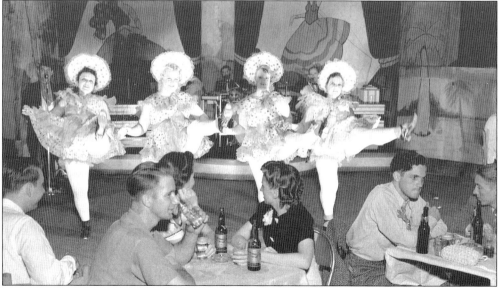

The Sunflower Girls were an early group of vaudeville singers that performed at area theaters and amusement parks. Their specialties were singing slightly bawdy songs and wearing silly outfits, as seen in this photograph. The songs were just blue enough to make the people laugh and blush at the same time. (Courtesy of the Western Historical Manuscript Collection, University of Missouri–St. Louis.)

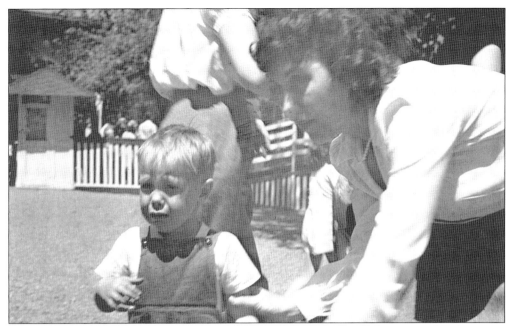

After enjoying a diet of cotton candy and Voss Red Crème soda all day, young folks' tempers may have a tendency to flare up. Here under her watchful eye, a young mother consoles her little boy, ensuring him that everything will be just fine so he can enjoy the rest of his day at Forest Park Highlands. (Courtesy of the Western Historical Manuscript Collection, University of Missouri–St. Louis.)

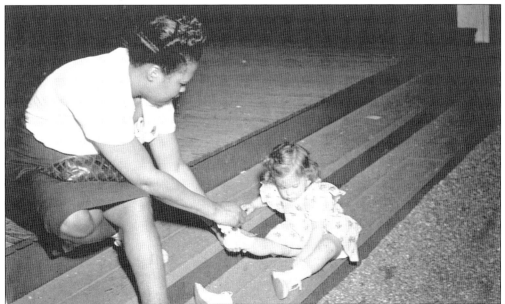

A small stone can be a big deal to a little girl enjoying her day at the Highlands. Here a mom helps her child get rid of any unwanted items that may have found their way into the little girl's shoe. Many parents took their kids to the Highlands at an early age as a right of passage because their parents before them did the same things. Many St. Louis children grew up at the Highlands. (Courtesy of the Western Historical Manuscript Collection, University of Missouri–St. Louis.)

The empty picnic baskets and cake containers sit on the floor as souvenir hunters do some last minute shopping at one of the many concession stands. Since the mid-1920s, the concessions were managed and operated by the Lewis family. Harry Lewis started there about 1923. He was very professional, always immaculately dressed in a crisp white shirt, black tie, and black pants. His dark hair always combed. He would always acknowledge his customer's presence and say "hi." (Courtesy of the Western Historical Manuscript Collection, University of Missouri–St. Louis.)

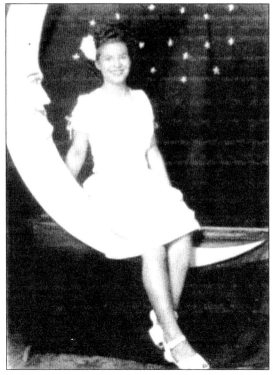

Lida Platz's studio had a few choices for posing in photographs. A person could sit on a fake horse that may or may not have a tail, depending on whether whoever stole it last had returned it. This attractive lass decided on a crescent moon. Her name was Rose Chiaurro, now Rose Kennedy. She worked with Lida Platz at her studio for a few years.

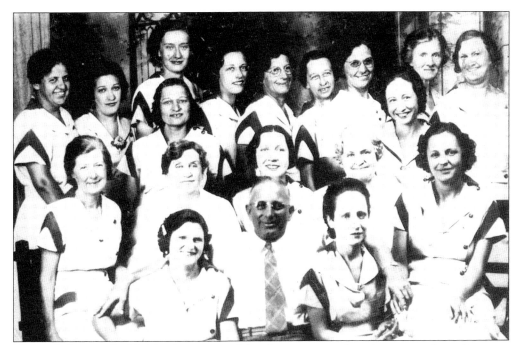

The work force at the Highlands was one of the closest groups of employees anywhere. Everyone was treated as if they were family. The group of women in this photograph was known as "the Highland Girls." They ran the cash registers. The man in the center is Max Bitterlitch, one of the most popular managers at the Highlands.

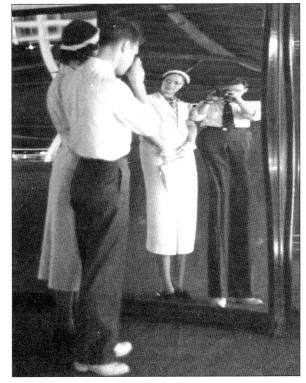

Fun house mirrors were always a staple of the temples of mirth in any amusement park. They either were standing side by side, or spread out and mixed in with other attractions, such as spinning platforms that whirled a person to the outer edges of a circular platform into a huddled mass of new-found friends. Here two visitors add to their photograph collection.

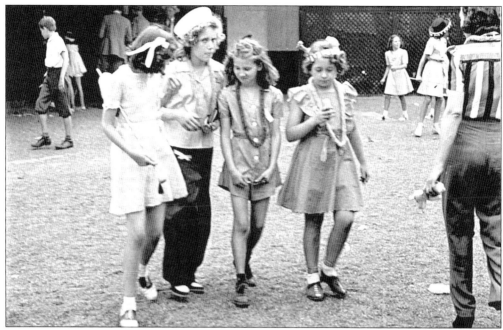

Four young girls enjoy a leisurely stroll on the grounds of the Highlands while showing their souvenirs to each other. The souvenirs, while not worth much then, have turned into pricey collectables that also restore old memories. Anything with "Forest Park Highlands" stamped on it can run into the hundreds of dollars. (Courtesy of the Western Historical Manuscript Collection, University of Missouri–St. Louis.)

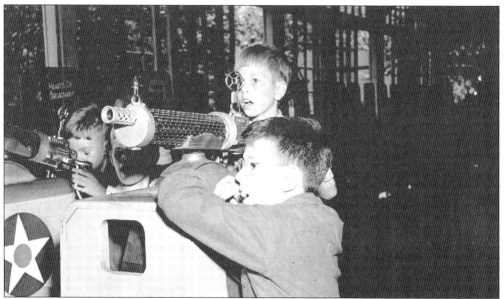

These future soldiers practice their gunning skills on this World War II inspired game. Here a person would shoot at targets, scoring each time he or she hit one with an infrared lighted machine gun. Many young soldiers, sailors, army men, and marines started their imaginary military careers on these games. During the 1960s, these types of games all but disappeared. (Courtesy of the Western Historical Manuscript Collection, University of Missouri–St. Louis.)

Four

THE FINAL YEARS

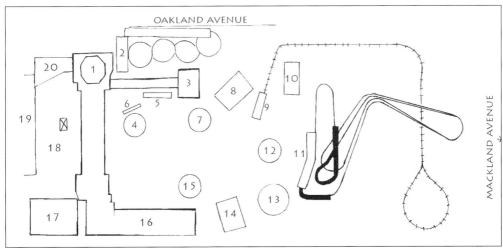

In its last years, the Highlands had the finest collection of amusement rides anywhere, including one of only seven Flying Turns ever built. The key to the map below is: entrance rotunda (1), Flying Turns renamed Bobsleds (2), arcade (3), Scrambler (4), Ferris wheel (5), Flying Cages (6), Tilt-a-Whirl (7), Dodgems (8), Little Toot (9), park offices (10), Comet (11), Aero-Jets (12), carousel (13), shooting range (14), Rockets Ships (15), dance hall and restaurant (16), fun house building, housing at various times boats, Bubble Bounce, and Cuddle Up (17), Kiddieland (18), swimming pool (19), and concessions (20).

The final version of the Highlands's entrance was remodeled in the early 1940s. Known as the entrance rotunda, it housed the ticket booths, as well as various food and souvenir concessions operated by the Lewis family. The upper section was used for park offices and storage for the concession stands. According to Don Lewis, the son of the concession manager, the octagon section was built over an earlier dome top.

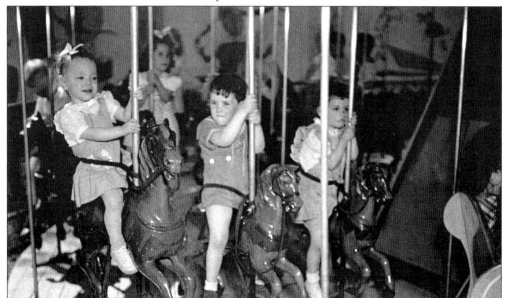

Young equestrians get their start on the children's carousel in Kiddieland. The kiddie carousel had extra straps to fit around its young riders, making sure they remained seated during the ride. These three young riders are taking their carousel ride seriously, holding on for dear life. Soon they will be riding on the larger Dentzel carousel on the other side of the park. (Courtesy of the Western Historical Manuscript Collection, University of Missouri–St. Louis.)

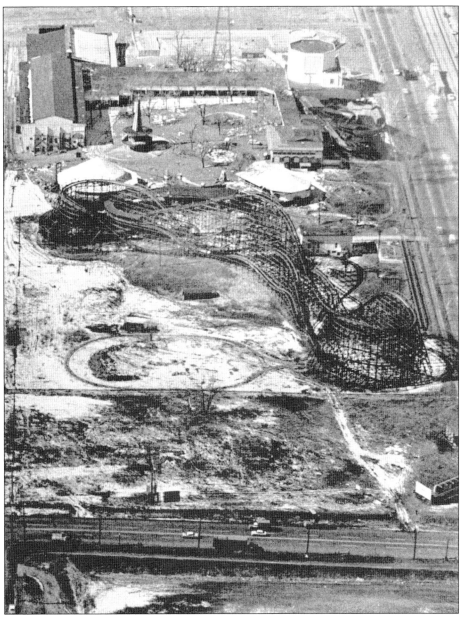

This aerial photograph shows the entire layout of the park looking west to east. Starting at the top left of the photograph is the old theater building which once housed the fun house, then various rides such as boats, Cuddle Up, and the Bubble Bounce. To the right is the public swimming pool. To the pool's right are Kiddieland and the steel flag tower. The white octagon-shaped building is the entrance. To the immediate right is the Flying Turns/Bobsleds. The arcade is to the left of the Flying Turns. It is connected to the dance hall and restaurant by a long L-shaped covered walkway. Forming the eastern border of the park left to right is the carousel. The space between the dance hall and carousel used to be the site of the park's shooting gallery. The Aero-Jets were on the right of the carousel, then the Comet, the parks magnificent roller coaster. To the right of the Comet's station was Little Toot, its route visible by the oval to the left of the Comet's structure. (Courtesy of Missouri Historical Society, St. Louis)

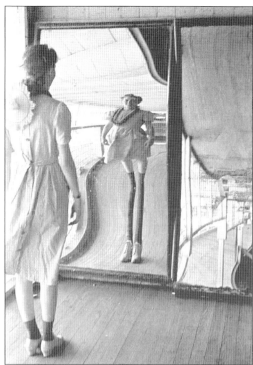

This girl with her souvenir hat perched on her shoulder seems frozen at the site of her newly extreme long legs stretched out by the distortions of the fun house mirror. Most peoples' first reactions looking into one of these distorted mirrors is one of disbelief, followed by hysterical laughter. (Courtesy of the Western Historical Manuscript Collection, University of Missouri–St. Louis.)

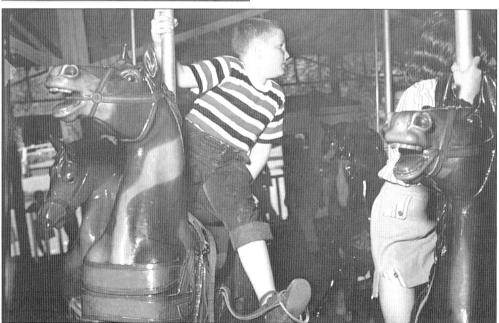

This rather well-fed little boy seems to be intent on heckling another rider instead of holding on to the pole. In spite of the Highlands's operators walking this ride while in motion, behavior like this would sometimes slip by the operator, but not very often. The first time a rider was caught behaving badly, a warning would be given. The next time, the offender would be removed from the park. (Courtesy of the Western Historical Manuscript Collection, University of Missouri–St. Louis.)

As years went by, some of the rides were remodeled with newer cars and new fencing, as shown here. The larger cars on the Kiddie Whip allowed bigger children to ride who were not quite tall enough to ride the larger rides. (Courtesy of the Western Historical Manuscript Collection, University of Missouri–St. Louis.)

Family picnics were always a part of the Highlands experience. Mom would secure a picnic table and arrange for a time to meet back for lunch or dinner of fried chicken and Voss Red Crème soda. White Castle hamburgers were also a favorite. Dad would usually show up after work with more money for the kids for extra rides and to finish off what was left in the picnic basket. (Courtesy of the Western Historical Manuscript Collection, University of Missouri–St. Louis.)

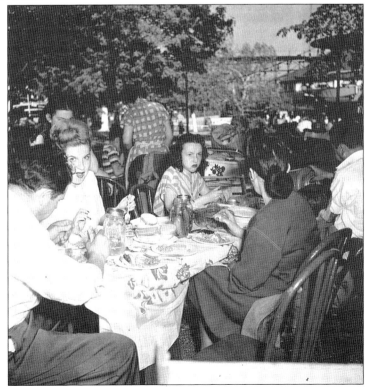

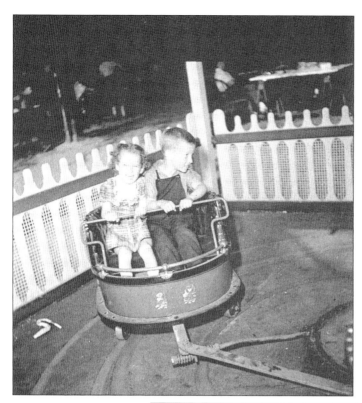

This early photograph shows two youngsters enjoying one of their first rides on the Kiddie Whip. The park's Kiddieland was on the west side of the park, sheltered by several large maple and oak trees. The concessions in this section of the park sold mainly snow cones and ice cream, just right for young appetites. (Courtesy of the Western Historical Manuscript Collection, University of Missouri–St. Louis.)

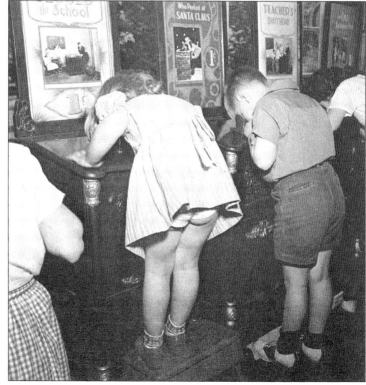

A young student is really involved in this arcade game based on school life, completely unaware of her immodest pose. The game is the Best Student in School. The students with the best grades really enjoyed these games, particularly those between the ages of 8 and 14. If a person was older, the games brought back fond memories. (Courtesy of the Western Historical Manuscript Collection, University of Missouri–St. Louis.)

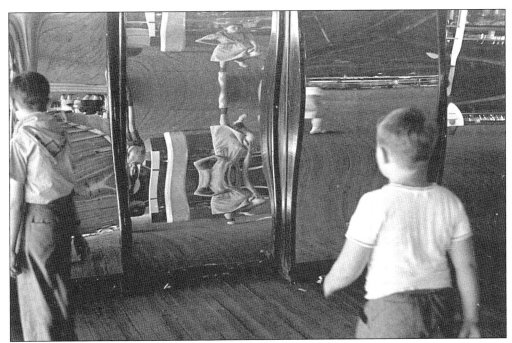

This little boy is probably wondering why the mirrors are making him look so funny. In one mirror he looks shorter and fatter; in the other mirror, he looks taller than his big brother. In a few years, as he progresses in school, he will learn about the differences between concave and convex mirrors and light refraction. The mirrors were set up at various locations in the Highlands after the Hall of Laughter was closed. The mirrors stood on the first floor of the dance hall near the restaurant. At other times, they were in the arcade building next to the Dodgems. In antique stores today, if the fun house mirrors have documentation, they would sell for several hundreds of dollars. (Courtesy of the Western Historical Manuscript Collection, University of Missouri–St. Louis.)

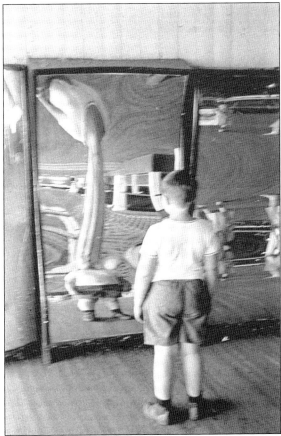

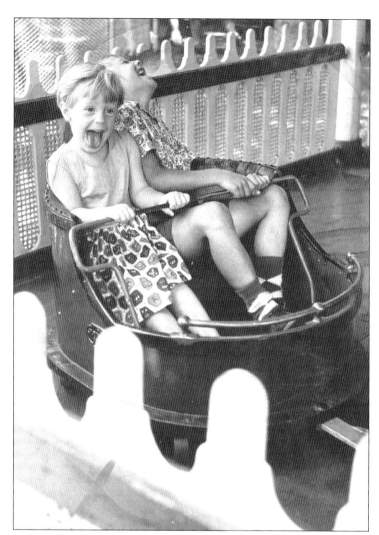

These two youngsters are having the time of their lives riding the Kiddie Whip. Any complete amusement park always had a Kiddieland, complete with every child-sized ride imaginable. Most parks had the tyke-sized rides grouped together a la Kiddieland. Sometimes the rides would be scattered among the larger rides.

Horace Mann School
PICNIC
FOREST PARK
HIGHLANDS
Thursday, June 9th, 1949
★ ◐ ★
The Attached Coupons Entitle Children
Under 12 Years of Age to the
Following Privileges:

4	ADMISSION TO MIRROR MAZE
5	ADMISSION TO BALCONY OF POOL
6	ADMISSION TO PARK

Cathy remembers "I was ten when the Highlands burned down. It was my childhood playground. My favorite ride was the Bobsled, but my brothers, sister, and I had an ongoing competition to see how many times in a row we could ride the Comet. I have not seen the carousel since its restoration, although I remember I had to always ride one of the jeweled horses. My dad was an electrician for the park, Stan Rimkus."

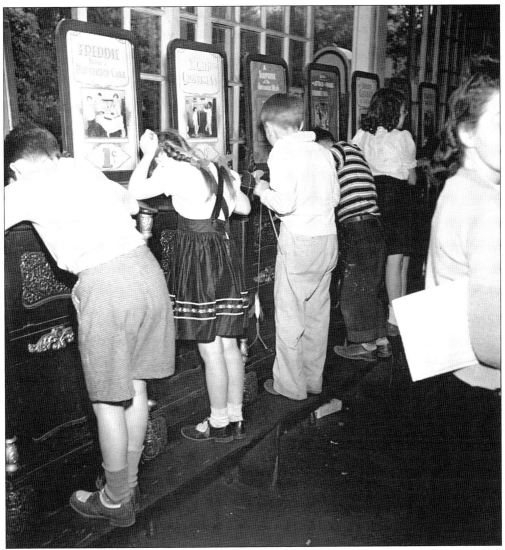

The young girl in the center of the photograph seems focused on planning a birthday party for perhaps her father or brother. The game she is so intent on is called Freddie Makes a Birthday Cake. This game was a favorite among young future homemakers. (Courtesy of the Western Historical Manuscript Collection, University of Missouri–St. Louis.)

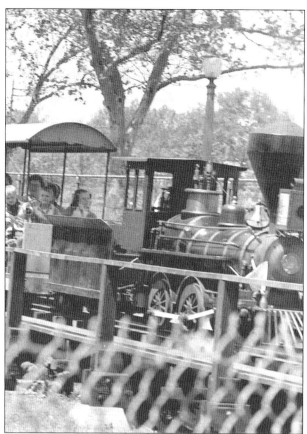

Little Toot gave visitors a wonderful break from the rigors of a day at the Highlands. A nice leisurely ride starting in the midst of the park, then traveling along Oakland Avenue through the Comet's structure, entering a large oval in an open field along Mackland Avenue, was the perfect respite from waiting in long lines. After the park closed, Howard Ohlendorf, who was instrumental in saving the carousel, managed to dismantle Little Toot with the help of a local Boy Scout troop and move the little steam locomotive to Tower Grove Park. The cupola was put behind a fence for safe storage. Some people were worried that Tower Grove might be turned into another Highlands, so the train was never set up. The last word was that Little Toot was sold to a park in the Ozarks. (Courtesy of the Western Historical Manuscript Collection, University of Missouri–St. Louis.)

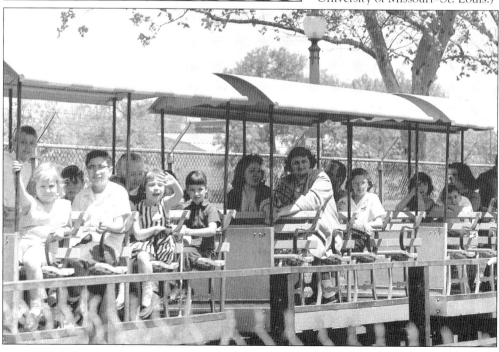

The Silver Jets are giving rides to budding astronauts no matter what direction they are flying in. Not only were their vehicles changed over the years (gondolas, biplanes, jets), the actual structure was redecorated too. Originally, the ride's steel structure was boarded at ground level and the steel was exposed looking like a large erector set. First, the loading platform was raised to a second story level, using a staircase inside of the structure to climb up to the platform. In later years, a red and yellow canvas covering was added to give some color and a new modern look. (Courtesy of the Western Historical Manuscript Collection, University of Missouri–St. Louis.)

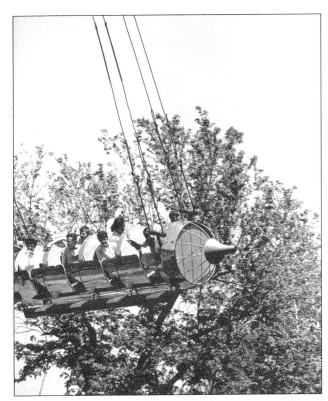

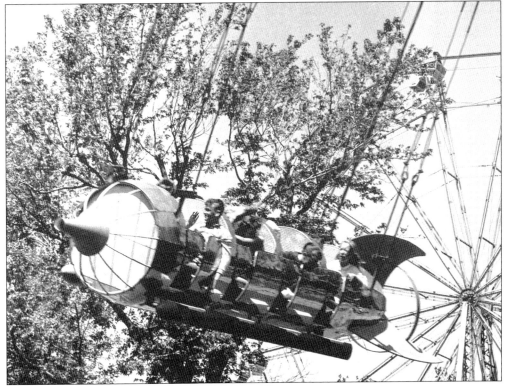

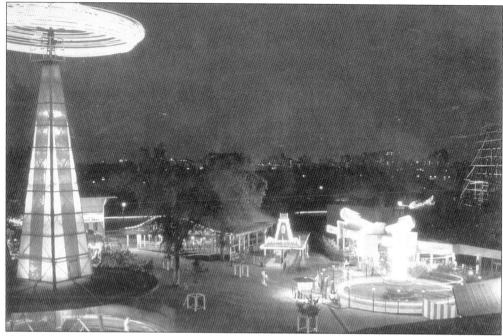

This 1960 nighttime photograph shows the magic amusement parks possess after the sun goes down and the lights get turned on. This photograph was taken by concessions manager Don Lewis from the now-closed dance hall balcony. From left to right are the Circle Swing, Dodgems, Little Toot, the Comet station, and the Aero-Jets. The crowds had dwindled quite a bit since the Highlands heydays in the 1940s.

This little boy is enjoying his first ride on one of the several rides at Kiddieland. The children's section was almost set apart from the rest of the park. The west border was the public pool, the north border was concessions, the east was a covered picnic pavilion and the steel flag tower, and the south was the fun house building. The steel structure disappearing out of the top of the picture is the park's flag tower.

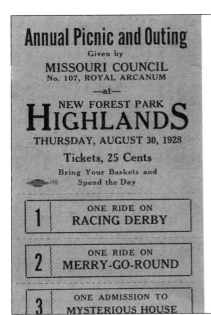

Annual Picnic and Outing

Given by

MISSOURI COUNCIL
No. 107, ROYAL ARCANUM

—at—

NEW FOREST PARK
HIGHLANDS

THURSDAY, AUGUST 30, 1928

Tickets, 25 Cents

Bring Your Baskets and
Spend the Day

1	ONE RIDE ON **RACING DERBY**
2	ONE RIDE ON **MERRY-GO-ROUND**
3	ONE ADMISSION TO **MYSTERIOUS HOUSE**

FOREST PARK HIGHLANDS
"The Big Place on the Hill"

Many new attractions have been installed this year

"The Mysterious Knockout"

The First in the United States
The Amusement Sensation of the Century

Janet of Colorado Springs remembers, "I was born in 1954 and some of my earliest memories are of the Highlands. I do remember the Bobsleds—what a thrill! Memories are alive, not just of the park, but the memories of relationships that are in the past. My dad has passed, but I always will remember the good times we had together at Forest Park Highlands."

The Ferris wheel and the Tilt-a-Whirl were two of the Highlands's milder rides but would still give riders just the right amount of thrills. The Ferris wheel faced west, giving riders a view of the St. Louis Arena in the distance and to the right the Flying Turns/Bobsleds. These two rides were among the few that survived the 1963 fire.

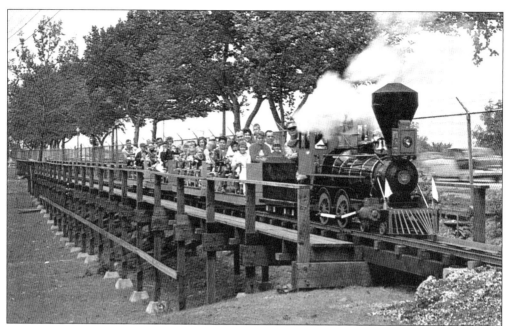

Little Toot, the park's miniature railway, gave riders an up-close-and-personal view of the park's roller coaster, the Comet. The steam locomotive traveled through the Comet's structure near the bottom of the first drop, exiting out the other side, making an oval and turning back for a second ride though the structure. Little Toot's loading station was to the immediate right of the Comet's station.

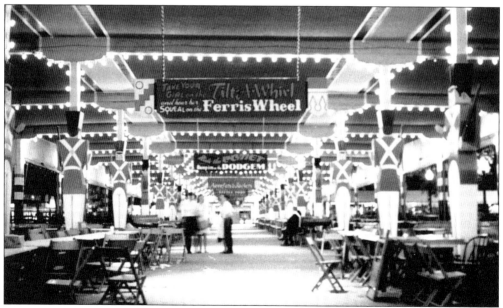

The covered picnic area led from the main entrance to the back of the park, connecting the park's dance hall and the old fun house building. Large toy soldiers held up the roof of the structure. Signs that would rhyme in describing the park's rides would hang from the ceiling. "Take your girl on the Tilt-a-Whirl, and hear her squeal on the Ferris wheel," and "Make Mom poot on Little Toot" were but two examples. This photograph was taken by Don Lewis.

This is one of the smaller concession stands in the park. This one is a snow cone stand, perfect for St. Louis's hot summer days. It stood at the base of the park's 120-foot steel flag tower on the west side of the park. Three generations of the Lewis family operated the concessions—Harry Lewis started in the early 1920s, his son Don started in the early 1930s, and Don's son, Don Jr., started there July 19, 1963, the day of the fire.

Linda from San Diego, California, recalls, "I don't know if it would be possible to make my children understand my passion for the Comet, Flying Turns, and the rest of the Highlands. I can almost envision me being there, the sounds of the Comet made as it went up the first hill, and the Flying Turns swooshing and swaying back and fourth, one of my very favorite rides of all time."

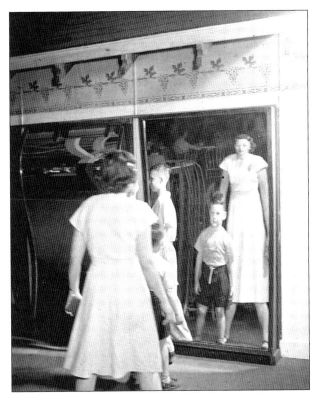

The girl in this photograph seems to be enjoying her newly gained, but faux, height over her little brother; he seems to be having second thoughts about his now tall sister. Fortunately for him, everything will turn back to normal once they walk away. (Courtesy of the Western Historical Manuscript Collection, University of Missouri–St. Louis.)

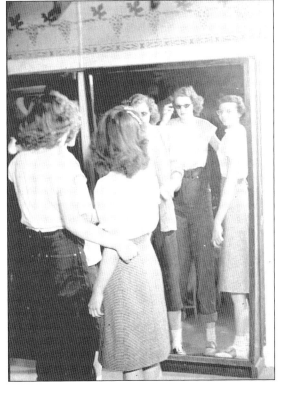

These three girls are picking the wrong mirror for checking their make up. These mirrors are just for fun. All three young ladies are up to date with the fashions of the day, sporting long pencil skirts and black and white saddle shoes complete with red soles, a staple of the 1940s and 1950s. (Courtesy of the Western Historical Manuscript Collection, University of Missouri–St. Louis.)

The Ferris wheel at the Highlands was 65 feet high. It faced west for a good tall view of the surrounding sights, including the arena. Turn to the right, past the Flying Turns, and one could look out and see people playing baseball at Forest Park. There is some conflict about where the Ferris wheel went to after the fire. Some people think it went to Holiday Hill; some St. Louisians think it ended up at Chain of Rocks. (Courtesy of the Western Historical Manuscript Collection, University of Missouri–St. Louis.)

Women loved the arcade games, too. The games were not just a guy thing. Most of the bolder ladies would head over to Rajah the Magic Crystal Gazer Love Meter Machine. The crazy machine was more of a fortune teller than a game. It even had a sign that rather personally asked, "Are you a five star lover?" (Courtesy of the Western Historical Manuscript Collection, University of Missouri–St. Louis.)

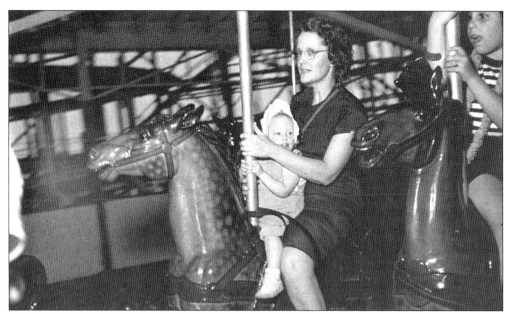

This little girl is enjoying what is probably her first carousel ride at the Highlands. Soon the very young lady will be big enough to explore the structure of the Comet in the background. The Dentzel carousel was originally hand carved for a dairy show at the arena next door in the early 1920s. Once the show closed, it was purchased for the Highlands and moved next door. This ride is still thrilling young and old riders alike at Faust Park in Chesterfield, Missouri. (Courtesy of the Western Historical Manuscript Collection, University of Missouri–St. Louis.)

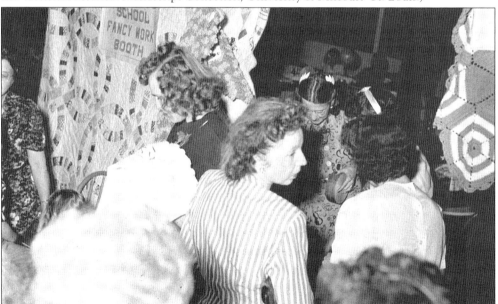

The covered picnic pavilion was also used for social events. Quilting shows drew hundreds of women perfecting their sewing skills. Quite often the crowds would be so large they would spill out into the main part of the park. In this shot, women are checking out the wares in the "Fancy Work" section. (Courtesy of the Western Historical Manuscript Collection, University of Missouri–St. Louis.)

The young male teenagers preferred games like the Atomic Bomber. Years before, the fellows could watch movies at the stand up movieola machines. "Our Gang Shine Stand" and "How Charlie Fooled the Cop" were favorites among the younger crowd. The few surviving machines are now considered valuable collector's items, as are the tokens it took to play them. (Courtesy of the Western Historical Manuscript Collection, University of Missouri–St. Louis.)

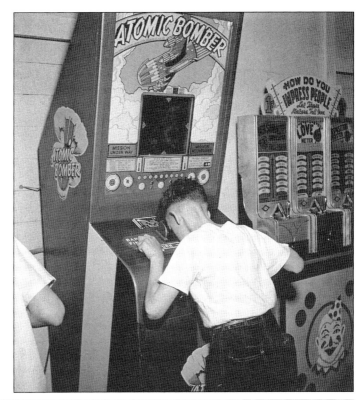

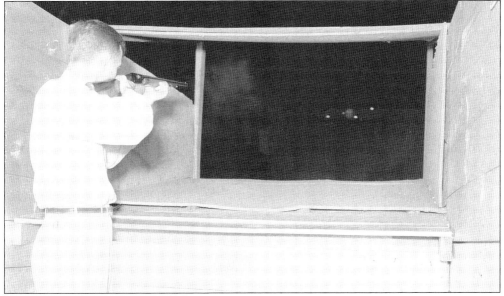

One of the shooting galleries was called the Happy Hunting Ground, a name that was used in referring to the dance hall for completely different reasons. Here marksmen could win prizes like hand-painted plaster collie dogs, now referred to as chalk ware. There were other prizes, such as a fringed bed lamp, Popeye, and the Lone Ranger who looked suspiciously like Teddy Roosevelt with a mustache. (Courtesy of the Western Historical Manuscript Collection, University of Missouri–St. Louis.)

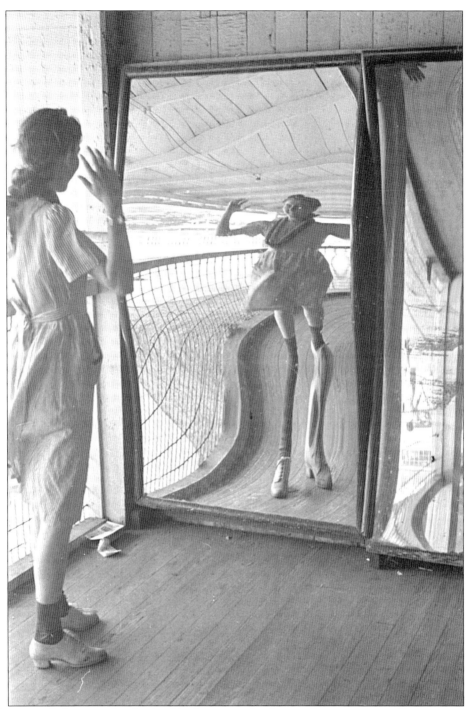

This young lady, once the shock of looking into the distorted mirror wares off, starts to react to her absurd appearance. The mirrors always tickle the funny bone and people react in many different ways. People usually pose in strange positions, until the uncontrollable laughter sets in. Many times friends will have to drag the posers away from their distorted images. (Courtesy of the Western Historical Manuscript Collection, University of Missouri–St. Louis.)

These two teenage girls are able to let out their frustrations on the Dodgems. Head-on collisions were forbidden, as riders were supposed to travel in a simple oval course trying to dodge or bump the other drivers. In the later years the Dodgems were known as the Bumper Cars. (Courtesy of the Western Historical Manuscript Collection, University of Missouri–St. Louis.)

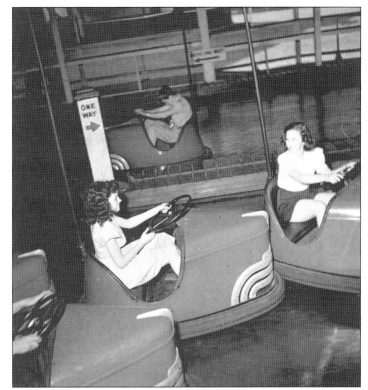

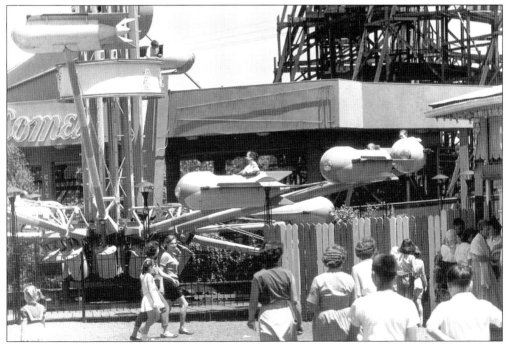

It is a good day at Forest Park Highlands. The Aero-Jets are fully loaded with would-be astronauts. The Comet station probably has a long line and there are crowds on the midway. Some seasons were better than others. Usually when a new ride was added, the crowds would swarm in.

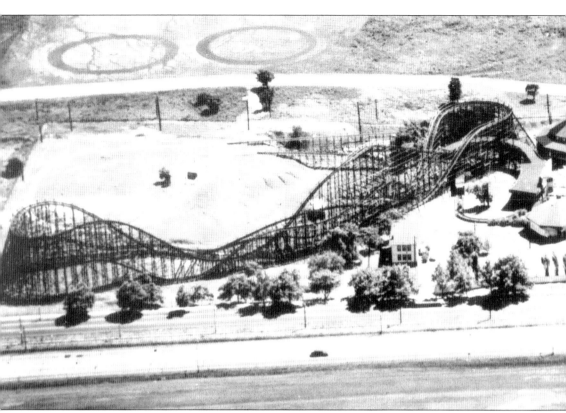

This aerial photograph shows Forest Park Highlands in its prime. Little Toot had not been put in yet. The miniature railway was the Century Flyer. It was located on the south side of the park. On the east side of the park, from left to right, are the Comet, the Stratoship, Century Flyer, and the carousel. Next to the carousel is the shooting gallery. Forming the south side of the park is the dance hall. The small round dots at the right side are the tables for the beer garden. The fun

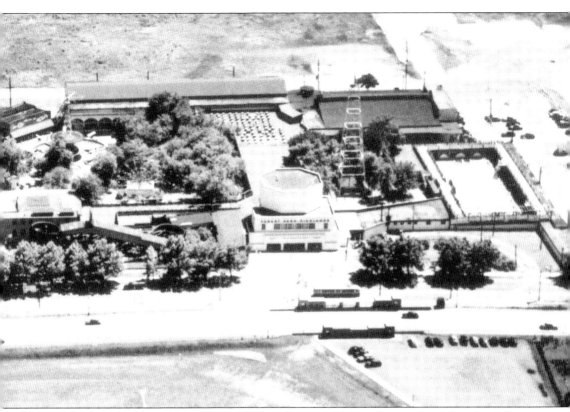

house is the large building at the upper right-hand corner. The pool is on the right side of the photograph, and then along Oakland Avenue are concessions, the entrance, Flying Turns, and the arcade, then the Dodgems. The spinning rides are situated among the trees. (Courtesy of the Western Historical Manuscript Collection, University of Missouri–St. Louis.)

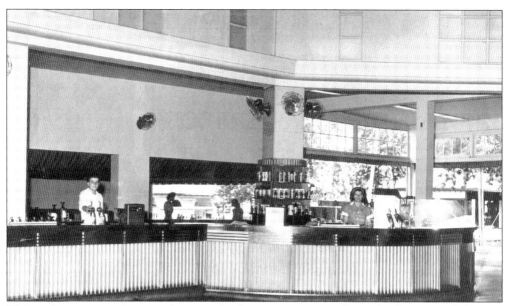

This early morning photograph is inside the entrance rotunda at the largest and fanciest ice-cream stand at the Highlands. Here are members of the Lewis family behind the counter waiting for the crowds to start pouring in. Most members of the Lewis family had worked at the park at one time or another.

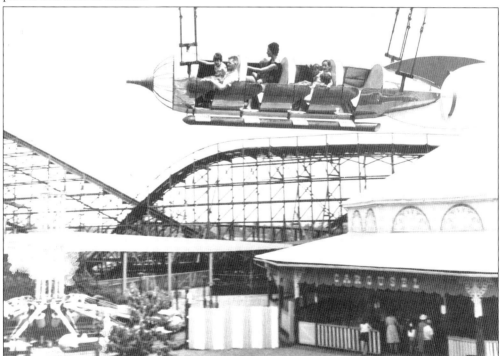

In this photograph, the older miniature train ride has been replaced by Little Toot on the north side of the park. The entrance to the former train is now blocked off by a striped fence between the Aero-Jets and carousel. The large Silver Jets are in full flight, replacing the small biplanes in the early 1940s.

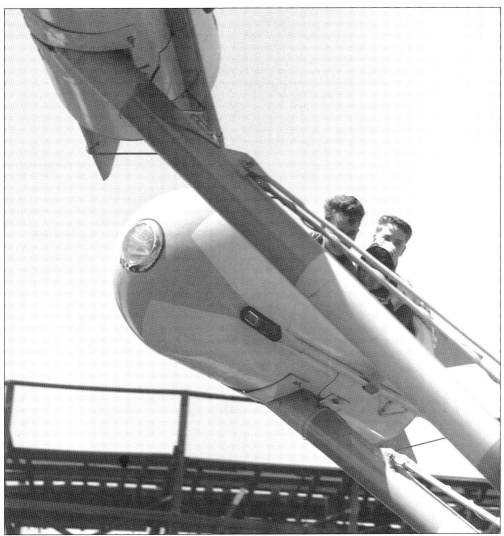

These three boys fly high above the Highlands as they streak by the Comet's structure on the park's new $50,000 Aero-Jets. The ride replaced an earlier ride called he Stratoship. It was a large rocket-shaped car attached to a steel arm with a counter-weight at one end. The arm would rotate, and then as the rocket ship part would start to go upside down, the passenger section would also rotate, so the riders would never actually be upside down themselves. In this new ride, the junior astronauts are able to control each jet with a center joystick, make their jet raise 20 feet or lower it to ground level. The Aero-Jets were manufactured in Germany. (Courtesy of the Western Historical Manuscript Collection, University of Missouri–St. Louis.)

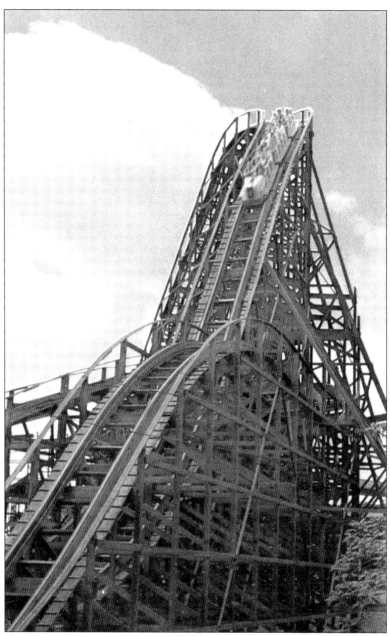

The Harwells of Kansas City remember, "My husband and I are both from St. Louis. I lived close enough to the swimming pool, but after the fire, I never went back there to swim because it was too sad to see the destruction. The elementary school I went to always had its school picnic at the Highlands, and we spent a lot of time deciding what we would wear, which rides we would go on first, and when we would meet our families to eat a few bites of lunch before heading off again. A couple of weeks before the big event, the PTA sold Highlands tickets—three for 25¢, one ticket for the carousel, one ticket for the Bobsled (my favorite), and one for the airplane swings. I was about eight years old when my brother took me on the Comet for the first time. I was really scared but I loved it so much I had to go on it again immediately. My favorite part was the small dips, but the long wooden tunnel provided the anticipation."

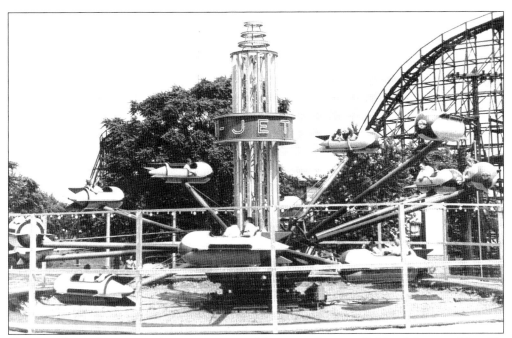

The Aero-Jets ride is shown here in its original location closer to Oakland Avenue. The ride premiered at the Highlands in May 1956. The ride sat in a 175-foot circle. Riders could raise the small jets 20 feet by pulling back the center control in each jet. The ride operator had a master control in case small-fry riders tried to stay in the air when the ride was over.

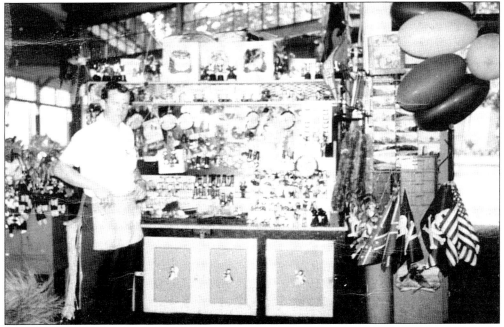

Don Lewis stands in front of one of the many concessions operated by his father, Harry Lewis. The concession stands offered every kind of souvenir imaginable: balloons, felt pennants, plates with images of the entrance rotunda, anything that would remind one of their visit to the Midwest's largest amusement park was here, all for a mere penny or two. (Courtesy of the Lewis family.)

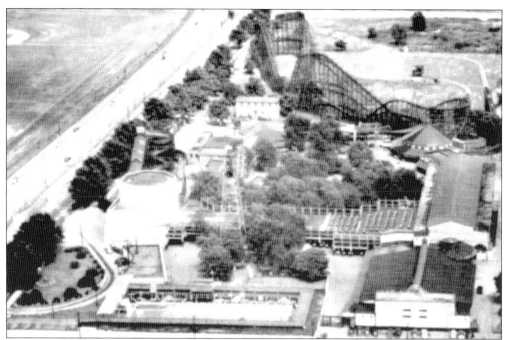

In this view looking east, the pool and the old fun house building are at the bottom of the picture. The rotunda is the white octagon-shaped structure to the left. The steel flag tower is in the center near the bottom half. The dots in a line are the tables for the outdoor beer garden. The long building on the right contains the dance hall and restaurant. The Comet forms the eastern border of the park at the top of the photograph.

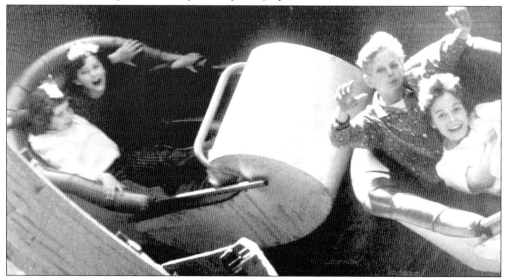

When amusement parks were having a slow season and the money was not there for large expenditures for capital improvements, often the park would redesign and repaint an old ride, then put a new name on it. In this case, the winged cars of the Flying Turns have been replaced by a more modern boxy type of vehicle. The ride was then renamed the Bobsleds. It was essentially the same ride, but with new cars. (Courtesy of the Western Historical Manuscript Collection, University of Missouri–St. Louis.)

Behind these three lovely children is the Comet's structure and station. In a few years the tykes will be in line for their first ride as well. The obscured sign at the railroad crossing is the "Century Flyer," the park's first miniature railroad.

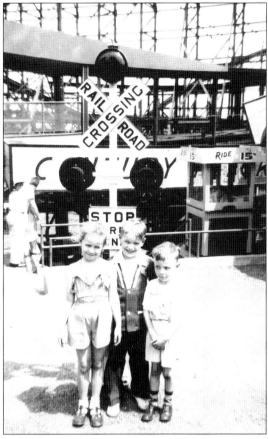

A lone rider enjoys a quiet ride by herself in Forest Park, while across the street, the Highlands offers rides of a more thrilling nature. The Comet always made a grand visual statement as one drove east or west on Route 40. The flag tower could be seen for miles and was considered a St. Louis landmark.

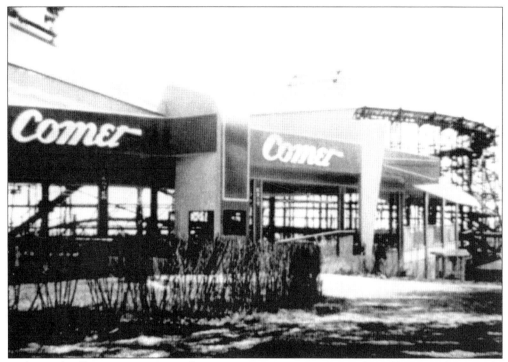

A deserted roller coaster station takes on a morose appearance in this off season photograph. The three sets of coaster trains (not shown) are covered up with canvas. The flat steel rails on the wood track that the coaster rides on have a coating of winter protectant on them that will have to be removed in early spring. The hedges have had their winter haircut but soon the Comet will be full of riders and the hedges will be full of green leaves.

Suzie from St. Louis recalls, "I only visited the park twice but have very vivid memories of the roller coaster (which I had forgotten was called the Comet), and the Bobsled, and my personal favorite, the carousel—which I visited and rode again at Faust Park. My dad was a coaster fanatic and adored riding the Comet."

Five

THE COMET

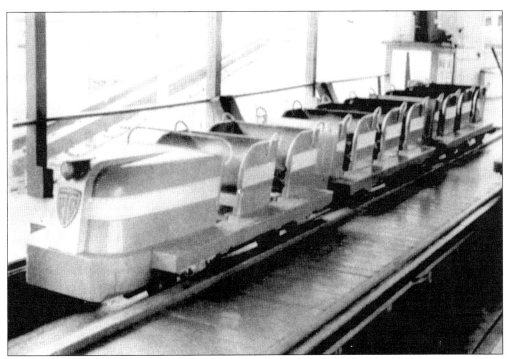

A spare train sits on the transfer track awaiting riders. Quite often a roller coaster operator would rotate the trains of cars, especially when three sets of trains were available. That kept maintenance on the trains down, as each train had a third of the wear. When rainy days would keep attendance to a lower level, only one train would be used. Many times the tracks would be wet, which would get the brakes damp. On such occasions, riders would sometimes be treated to an extra ride when the coaster train would slide through the coaster station for a second go-round. (Courtesy of Ken Rutherford.)

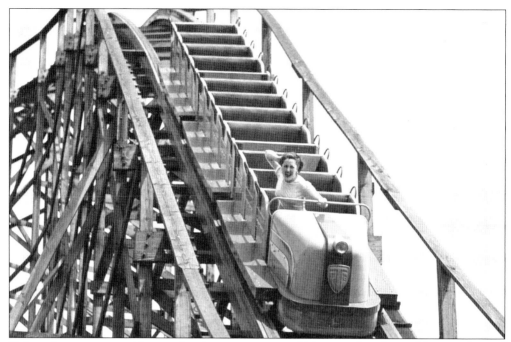

Before the coaster would open for the season, it would be tested with sand bags or bags of gravel. Occasionally a lucky person or a park employee would get a free pre-season ride. This young lady, hanging on for dear life, was one of the lucky ones. She was a reporter for a local defunct newspaper.

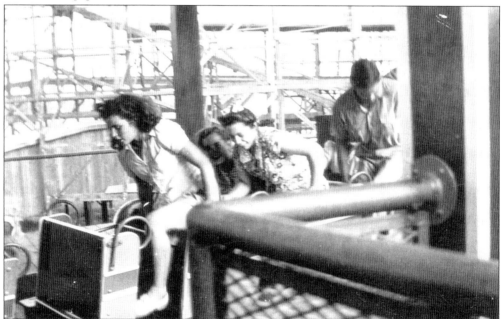

In this 1942 photograph, a group of friends board the Comet roller coaster. The caption on the back reads, "Molly and Rebecca enjoy a day on the Comet." Notes on the back say they rode it 45 times. Apparently these girls would go for marathon rides on the Comet. Occasionally there would be articles reporting that people rode the Comet more than 500 times in a row.

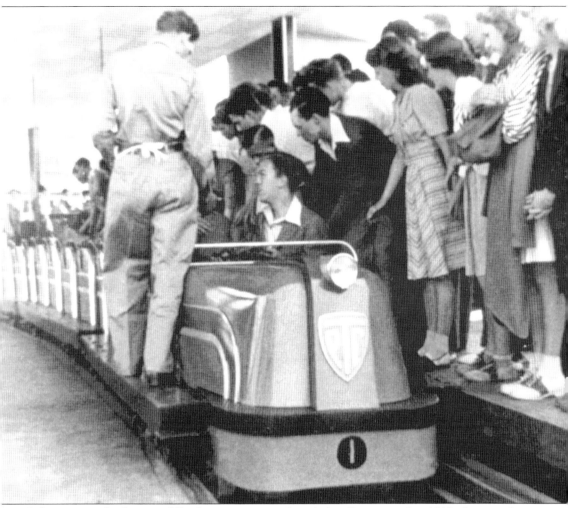

Girls wearing the latest saddle shoes prepare to board the Comet in this 1940 photograph. Comet cars were four bench seats, two to a bench, except for the front car. The elongated fronts took up the first two seats as well as giving them the look of a real automobile. Very striking, the cars' color combination was purple and yellow. Each car had its own individual set of stripes. The side boards that the passengers would step on when they boarded were a vivid red. The cars were unique in another way. They had a single front headlight that would light up inside the tunnel. Stationary lap bars and side rings were the only safety devices that held the rider in. Later seat belts were added. Just 23 years later, these coaster cars would look quite a bit different. (Courtesy of Ken Rutherford.)

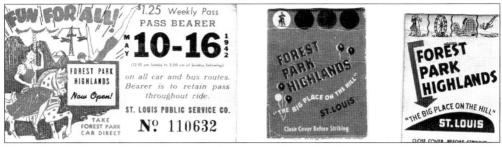

Harry from St. Louis says, "Looking back, I can remember all of us screaming at the same time as we got closer and closer to you know where. Turning right onto Oakland Avenue from Hampton Avenue, the Highlands were finally visible. We were home. We were at what I pray heaven would be like. We were at Forest Park Highlands. My all-time favorite ride was the Bobsled. I would ride until my parents stopped giving me money, or until I threw up. I only rode the Comet once. It scared me."

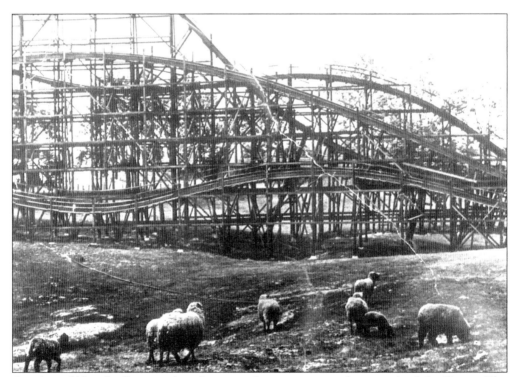

A rather odd but fondly remembered site was sheep grazing on the grounds of the Comet. The groundskeepers would bring in the sheep. They would keep the weeds down and the grass cut. It was a very inexpensive way to cut down on the work load of the yard workers. The roar of the Comet never seemed to bother the sheep.

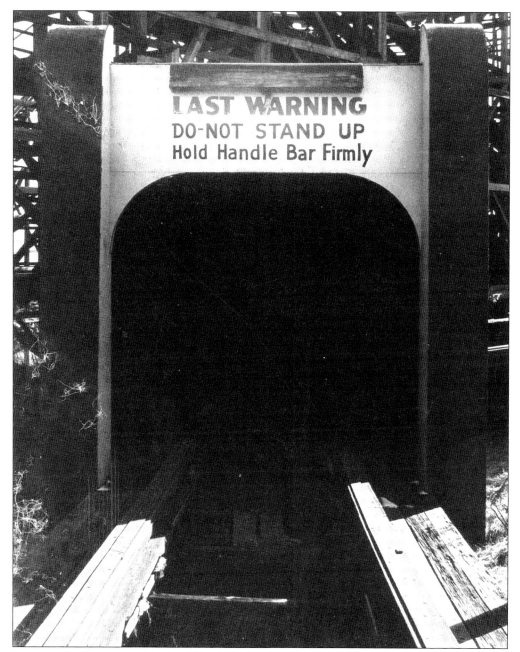

LAST WARNING
DO-NOT STAND UP
Hold Handle Bar Firmly

Every good roller coaster ride should begin with a nice long tunnel. The Comet was no exception. The land that the Comet was built on had gullies and dips, so Herb Schmeck, the designer, used that to the coaster's advantage. The tunnel hid a few surprises, unexpected dips here, surprising turns there. The Comet's tunnel was 300 feet long, making it one of the longest roller coaster tunnels anywhere.

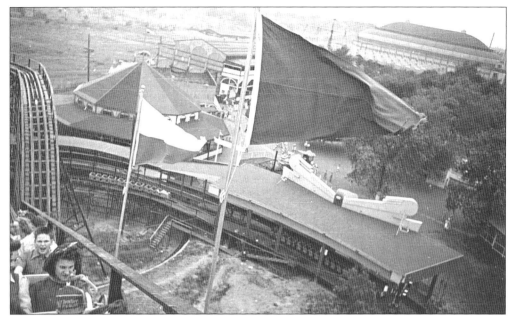

This near aerial view of Comet riders shows the entire south half of the Highlands as well as the St. Louis Arena in the distant background. As this train starts its perilous journey, two other trains sit in the coaster station, one on the transfer track and one ready for boarding. (Courtesy of the Western Historical Manuscript Collection, University of Missouri–St. Louis.)

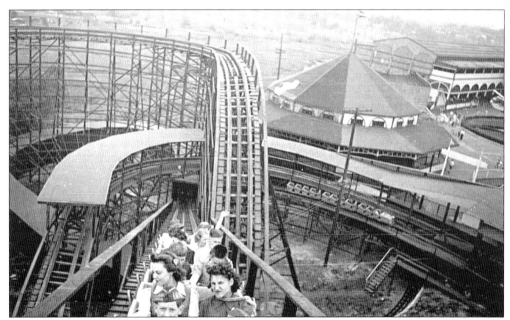

Riders begin the assent on the Highlands star attraction, the Comet roller coaster. A fully loaded train assures a faster ride: the heavier the train, the more speed it has. The coaster's tunnel, the carousel, and the dance hall are also shown in this photograph. On tall rides like a coaster, riders can see behind-the-scenes maintenance, such as the carousel's roof repair. (Courtesy of the Western Historical Manuscript Collection, University of Missouri–St. Louis.)

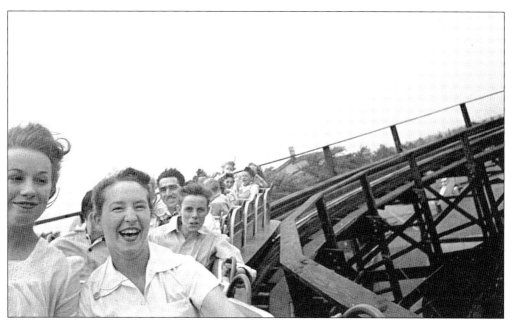

As the Comet rounds the curve above the coaster's art deco–styled station, these young ladies get a lesson in lateral g-force, the force that pushes a rider to one side or the other. Flat curves produced more lateral g-forces than banked curves. This sensation usually produces giddy laughter as opposed to screaming. (Courtesy of the Western Historical Manuscript Collection, University of Missouri–St. Louis.)

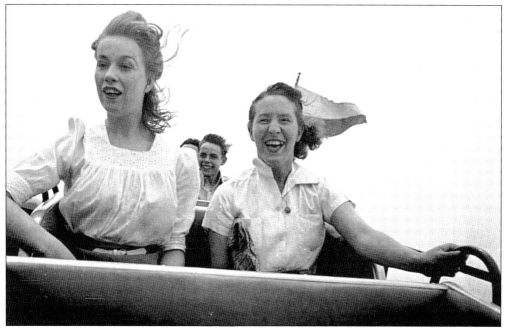

This rider seems to be wearing a flag that is waving in the background. The roller coasters built in the 1940s did not have interlocking or ratcheting lap bars to hold in passengers. Rider behavior was different, so all that was usually needed was a stationary lap bar or the side rings shown here. (Courtesy of the Western Historical Manuscript Collection, University of Missouri–St. Louis.)

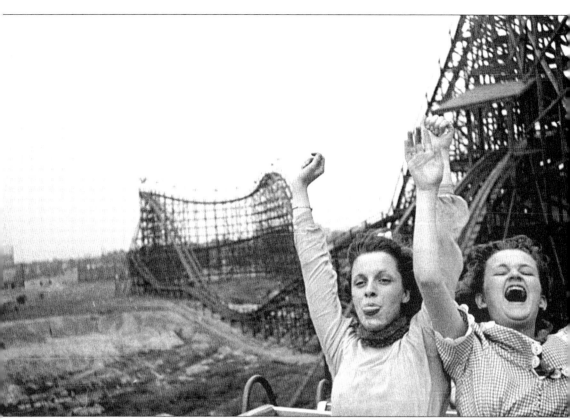

The riders on the first circuit of the Comet on opening day mug for the photographer. The Comet was the most popular ride in the park and was considered one of the best designed coasters ever built. The ride was 460 feet from the station to the lift hill; from the top of the lift hill to the brakes was another 2,160 feet. The total length, according to blueprints, was 3,120 feet. (Courtesy of the Western Historical Manuscript Collection, University of Missouri–St. Louis.)

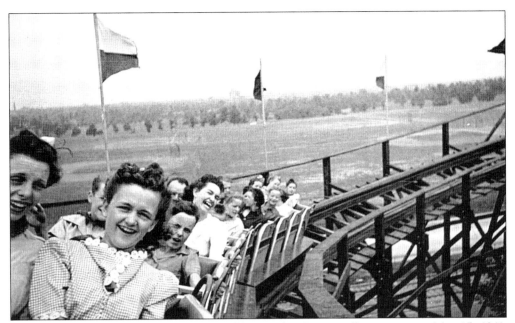

Riders enjoy the first ride open to the public on the Comet roller coaster on May 15, 1941. Each coaster car could carry a total of eight people per car, except the front car, which, due to the extended front, could only fit six, for a total of 22 riders. On some occasions, if the riders were small, three people could fit in a seat. (Courtesy of the Western Historical Manuscript Collection, University of Missouri–St. Louis.)

The Comet descends the second part of a curving double-dip midcourse on the ride. Just over 3,000 feet long, the entire ride lasted only two minutes. Children on school picnics were always trying to up-trade their tickets of the milder rides for tickets on the Comet. Most people were torn between the Comet and the Flying Turns as to which was their favorite ride. (Courtesy of the Western Historical Manuscript Collection, University of Missouri–St. Louis.)

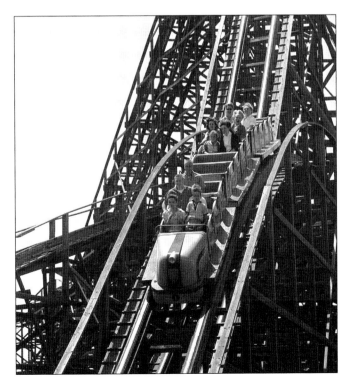

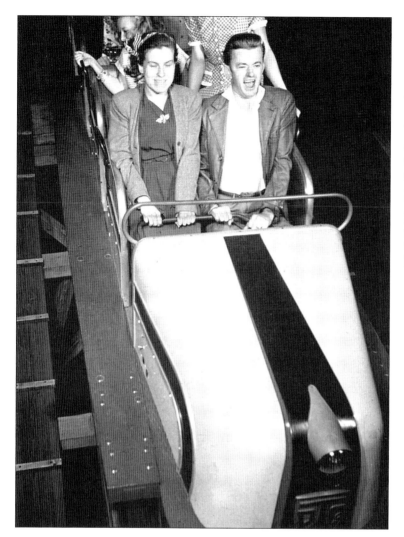

Streaking down a harrowing drop, these two riders clutch on to the lap bar for dear life. The steepest drop is only 48 degrees, but to these two occupants, the car seems to be standing on end. (Courtesy of the Western Historical Manuscript Collection, University of Missouri–St. Louis.)

Harry from St. Louis writes, "What I remember the most now is seeing Dad walking into the Highlands from work. I would run up and give him a big hug before we sat down at a park bench and had the dinner Mom had made for us. Everything a kid loves, all rolled into a 24 hour period. Dad would go on some of the rides with me while Mom stayed back laughing with the other moms."

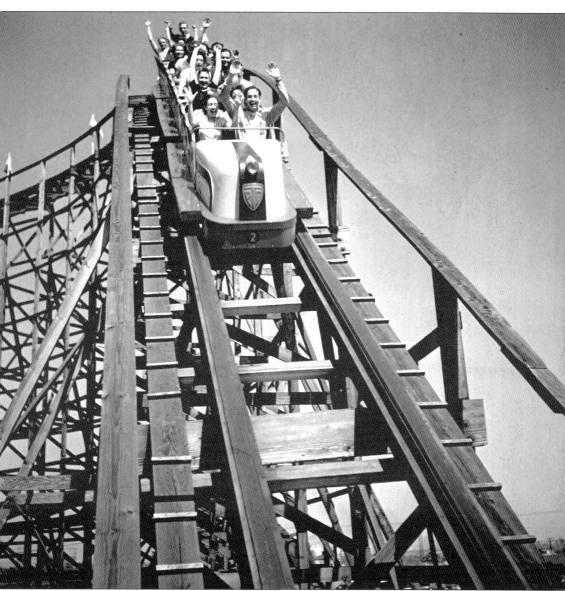

The Comet careens down its fifth drop off the station turn. The coaster's midcourse was located just above the station, just before this drop. The brake was not used to slow the ride down. It was more of a safety feature when using three trains; the brake ensured that a proper distance was kept between the trains so there would be no collisions. In spite of urban legend, the Comet has never jumped the track. Each roller coaster car has 36 wheels, keeping the cars locked on the tracks and the riders safe at all times. There are three sets of wheels on a wood roller coaster: under wheels, side-friction wheels, and finally the wheels that ride on the strip of flat metal that the cars sit on. These prevent any derailment. (Courtesy of the Western Historical Manuscript Collection, University of Missouri–St. Louis.)

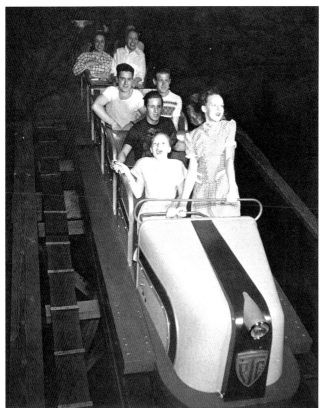

This young lady strikes a pose—a very dangerous one—riding in the first seat of the Comet. The Comet's first drop was from 46 to 48 degrees at about 85 feet. The stationary lap bars and her trim size made the dangerous feat possible. Most riders abided by the rules and remained seated once out of the loading station. (Courtesy of the Western Historical Manuscript Collection, University of Missouri–St. Louis.)

Mike from Westchester County, New York, writes, "Boy, do I miss the Highlands! Some of my most fun days were spent there as a child. I remember the picnic area with its tanbark-covered floor; the airplane swings: the Tipsy Cavern [walking spook house] with its orange-lit, tilt maze room; and the giant marionette outside with its hair hanging down. I live in Westchester County, and we have a park in Rye that reminds me a lot of the Highlands, at least in some respects."

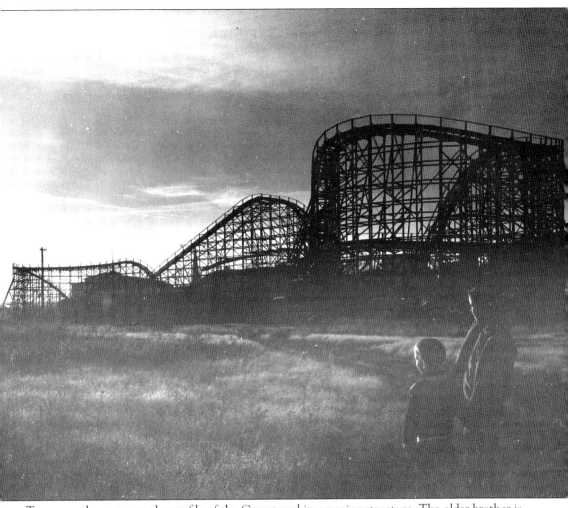

Two young boys gaze at the profile of the Comet and its amazing structure. The older brother is probably reassuring his little brother that in a year or two, he too will be able to ride the Comet and find out the coaster's best kept secrets. As the sun sets, the Comet forms a majestic silhouette against the disappearing sun. (Courtesy of the Missouri Historical Society, St. Louis.)

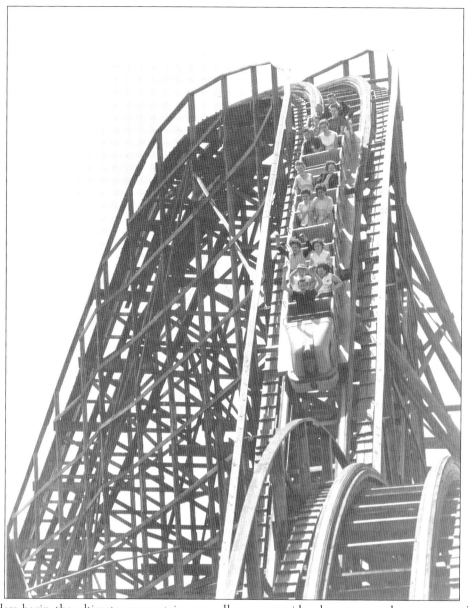

Riders begin the ultimate moment in any roller coaster ride, the moment the cars start the ascent of the first drop. The Comet stood at 90 feet tall, depending on who was asked. Originally the design was going to have a 180-degree turn at the top of the first hill, then drop. The design was changed due to space limitations, plus the up-and-over first drop was more esthetically pleasing. The Thunderbolt at Westlake Park had an up-and-over drop, and the other, smaller Comet at Chain of Rocks had a turn before its first drop. The Highlands's Comet had a little tweaking done during the building. Its first drop slightly turned before the ascent. This was used in several of Herb Schmeck's designs, most notably at Paragon Park's reconfiguring of their giant coaster. It was decided that the Highlands would save a lot of money if the treated wood was left unpainted. The other two coasters in St. Louis were painted white, which would chip off very easily in the hot St. Louis summers. (Courtesy of the Western Historical Manuscript Collection, University of Missouri–St. Louis.)

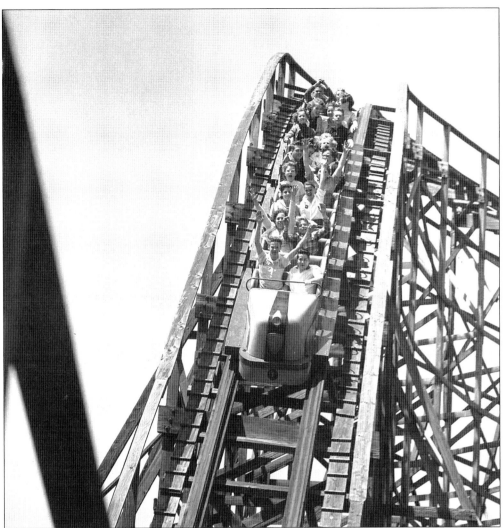

The Comet train is completely full of excited passengers. "Hands up" was almost a requirement for teenagers. Here the train begins its second drop off the first turn around. Herb Schmeck, the Comet's designer, pulled out all the stops when he designed this coaster. The Comet had swoop turns, flat turns delivering lateral Gs, twisted and curved drops, drops that curved at the top, and drops that were more like ramps. This was the cream of the crop in the 1940s. The station was unique among all coaster stations anywhere, and the cars were the only ones that had headlights that came on in the tunnel. The Comet was situated at the back of the park to make sure that once the people were in the park they would be drawn to the coaster and would notice what else the park had to offer. This way the lesser attractions were spotted, as well as the many concessions. (Courtesy of the Western Historical Manuscript Collection, University of Missouri–St. Louis.)

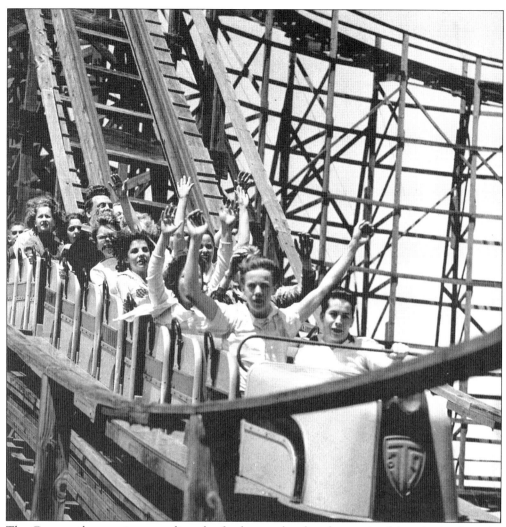

The Comet riders are just rounding the final curve heading home. At this point in the ride, there were three small hills known as "rabbit hops" that felt almost too small for the coaster's speed. Their design was for maximum negative gravity, which occurs when riders are lifted off the seats. If the rider were an eight year old boy, such as the author was, this section of the ride was usually spent riding on the underside of the stationary lap bar. If riders noticed a photographer, they would suddenly become more rambunctious and turn towards the camera to make sure they were seen. Many boys who would not hold up their hands would now try it, but quickly bring their hands back down immediately after the photographer got out of site. Most theme parks today have cameras set up at various points in the ride to catch the ham in every rider, for a price of course. (Courtesy of the Western Historical Manuscript Collection, University of Missouri–St. Louis.)

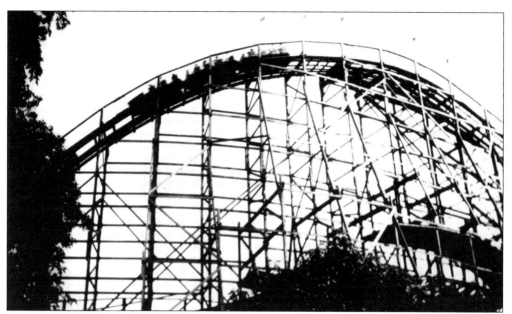

Comet riders enjoy the initial plunge of the first drop. This rare view was taken from the backyard of the old Highlands Hotel. The building was not really a hotel as such, but was so called because during the days of vaudeville, the celebrities who performed at the theater would stay there.

This photograph was taken while heading west on Oakland Avenue. This was the view that most people who lived in St. Louis remember. If the rider were a youngster or a teenager, it was especially exciting. The roller coaster's frail looking structure looked dangerous and fun at the same time. Once past the Comet, the Flying Turns/Bobsleds, and the Comet's tunneled lift hill would soon come into site. Then the rider would be straining his neck for one last view.

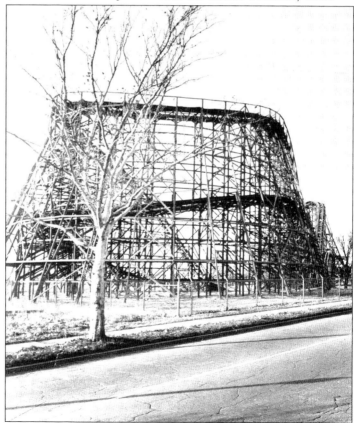

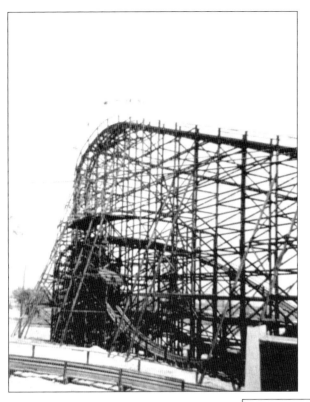

These two photographs were taken just after construction of the Comet was completed. Another two weeks of testing, and the ride would be ready for new passengers on opening day, May 4. The photograph at left shows the lift hill and sixth hill, as well as the approach track to the tunnel. The top third of the first drop was adorned with alternating flags in yellow and purple to match the coaster trains' colors. This photograph was taken looking east. The bottom photograph was taken looking west in the very center of the Comet's structure. Originally the Comet's first drop was supposed to be below grade, but building below ground level drives up the construction cost a great deal. Schmeck took his peers' advice and built the coaster 15 feet higher to avoid that issue. Many coasters are tweaked or changed from the original design. (Courtesy of Ken Rutherford.)

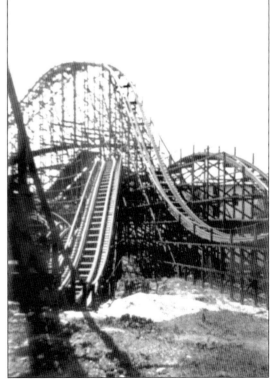

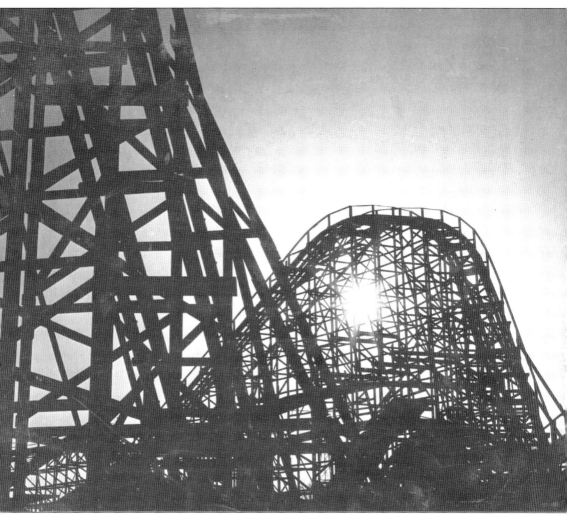

As the sun sets behind it, the Comet's lift hill, first drop, and first turn form an intricate pattern. This photograph was taken from inside the Comet's first turn, looking southwest. Photographers have considered roller coaster structures artful objects since they were first built in the late 1890s. Several artists have completed entire exhibits of roller coaster structures. One of the best ways to bring out the feeling of happy memories is to show photographs of first drops with people screaming as the coaster tops that first hill. But to see a photograph of a broken-down ride in disrepair or in demolition brings a feeling of sadness, like losing a pet or a friend. Many people will have their favorite photographs of their favorite roller coaster enlarged and spend hundreds of dollars to have the photograph framed, creating a very nice piece of artwork that is museum worthy.

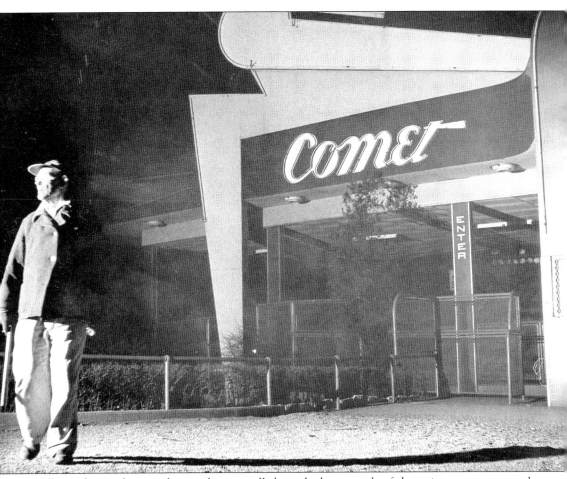

The night watchman takes a solitary stroll through the grounds of the quiet amusement park. The Comet station looks like some futuristic structure, maybe a spaceship station instead of a roller coaster. This particular design was considered one of the prettiest of any coaster stations anywhere. Architects not even involved in amusement parks would remark on its lines and angles. People noticed how the structure used the design of a Comet on its roof, matching the ride's name. The colors were purple and yellow to match the coaster trains. An ancillary benefit of the way this station was placed is that it hid a lot of the coaster's features; thus, the rider enjoys the surprise of the coaster's many twists and turns. Most coaster stations were just square shaped boxes or nothing more than a roof with four poles holding them up. The Comet's station was special, as was the park.

Six

THE FIRE

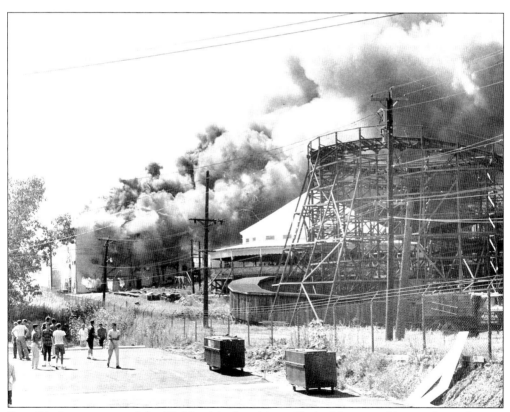

Stan Rimkus was one of the Highlands's electricians. He had been working at the park since 1958. He worked for the St. Louis Arena Corporation, which owned both the amusement park and the arena next door. From the arena on July 19, Rimkus was able to see the back side of the dance hall engulfed in flames. A call on his walkie-talkie confirmed his worst fears.

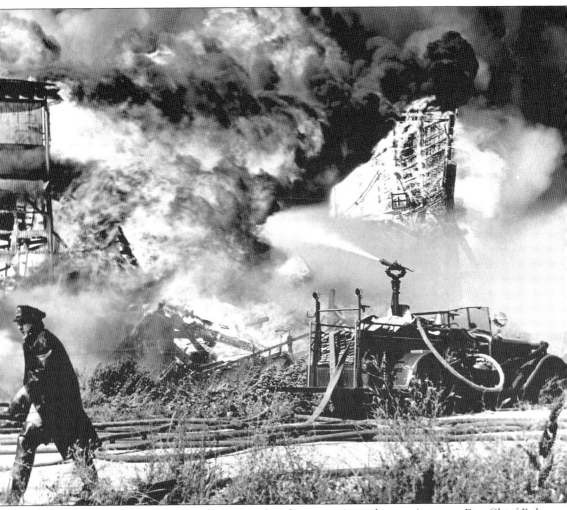

The fire started at approximately 2:30 in the afternoon. According to Assistant Fire Chief Bob Olson, the fire started in the basement electrical shop of the building that housed the dance hall and the park's major restaurant. Back at the snow cone stand, Don Lewis Jr. began to get very worried. In just a short time, the smoke wafting from the restaurant had grown into a sizable fire, with menacing red and yellow flames now reaching above the dance hall's roof. Just then the owner of the leased Ferris wheel, Johnny Miller, ran by yelling to no one in particular, "The dance hall is on fire!" Before Lewis could retrieve the day's cash receipts, hidden in the bottom of the snow cone stand, several firemen appeared as if from no where, ordering him to get out, yelling "The place is on fire! Get out of here now!" The dance hall was almost completely engulfed in flames. Some 260 firemen, including those off duty, were called in to help save one of St. Louis's most beloved attractions.

FOREST PARK
HIGHLANDS

JOY-BOOK

BRINGS JOY TO YOUR
HEART AND POCKETBOOK

COMPLIMENTS OF

FOREST PARK
HIGHLANDS

Coupons in this book will be
honored on all evenings after
7 p. m. and Sundays after
1 p. m. The Management re-
serves the right to take up or
cancel this book at any time
without notice.

Always bring your book.

Bill of Austin, Texas, remembers, "I grew up in a section of South St. Louis known as Dogtown. You could walk up the hill some one hundred feet or so and see the Highlands in all her glory. My pals and I sat on the steps in front of Ernest's house on Kraft Avenue watching the Highlands and our innocence go up in smoke, all of us in tears. We had lost part of ourselves. My mother worked for KWK, a local radio station. Their administration offices were in the west tower of the arena at the time. I remember that she and newsman Bill Gill covered the fire. Bill kept getting closer and closer to the fire. Mom was operating the remote vehicle inching so close her eyebrows and hair was singed. When I saw the implosion of the arena on CNN, I got that same feeling. I lost another part of myself."

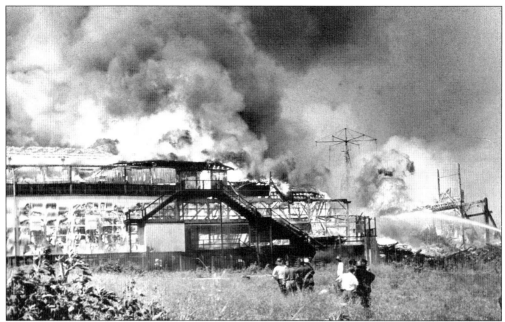

At approximately 4:00 p.m., the dance hall building started to collapse. The park's Circle Swing, seen here among the smoke and flames, had started to burn, but was still standing. The plants and flowers started to wilt, wither, and die from the intense heat and flames. The base of the tower, where one would walk up a flight of stairs to board, soon caught fire, weakening the tower structure and collapsing it into a pile of twisted metal. There were only 75 people at the park that day, including television personality Charlotte Peters, who was filming her show there.

The driver of Little Toot watches as the dance hall is destroyed by the July 19 fire. The building to the right of this photograph is the backside of the Dodgems. As the flames grew stronger and higher, they continued to advance toward the former Hall of Laughter. Firemen used the pool's water to try to fight the fire, but their attempts were in vain. The fire destroyed that building as well. (Courtesy of the Western Historical Manuscript Collection, University of Missouri–St. Louis.)

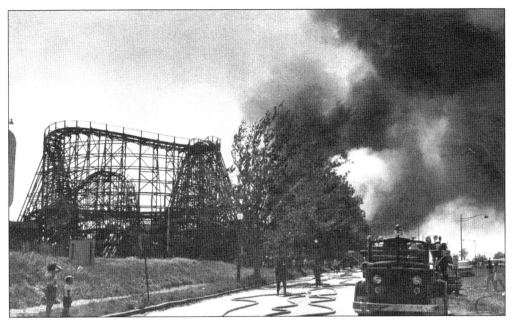

By the time this photograph was taken, most of the Highlands had been destroyed by the fire. People still lined the street watching the end of a St. Louis landmark. This photograph is looking west at the back end of the Comet. Oakland Avenue and Route 40 had been closed off because the pavement had started to buckle from the intense heat.

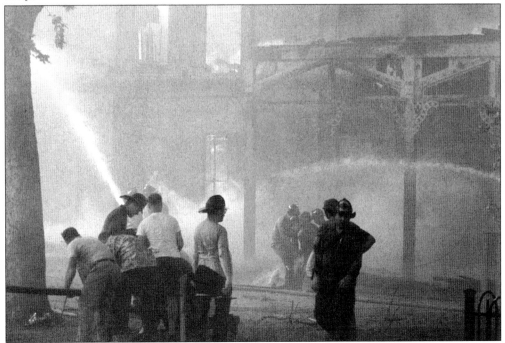

Female employees did not have time to retrieve their purses. Emergency pay checks were issued from the St. Louis Arena Corporation offices so employees would not be left without any money at all. By the end of the fire, all that was left of the old Johnson mansion/arcade/restaurant was a hollowed out shell and a small part of the second floor.

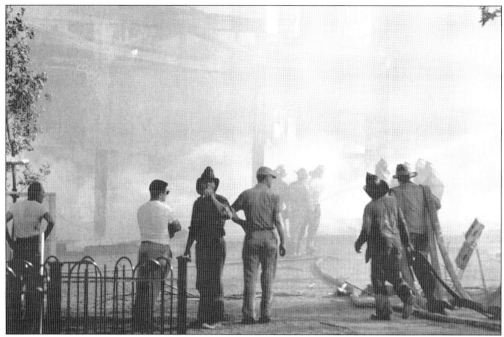

These two photographs show the devastation the five-alarm fire caused. Here the fireman and a few ride operators lament about the ferocity of the fire. By this time everyone had been evacuated from the park. Don Lewis Jr. gathered with friends on the west side of the pool, hoping that the fire could still be stopped.

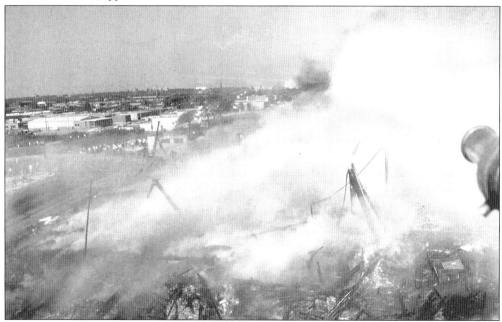

Firemen continue to douse the still smoldering ruins of the dance hall and restaurant to prevent any possibilities of flame-ups. This photograph is looking west. The barely upright structure leaning at a precarious angle was once the tower of the Circle Swings (Silver Jets). The fire lasted about three to four hours. It was still smoldering the next day.

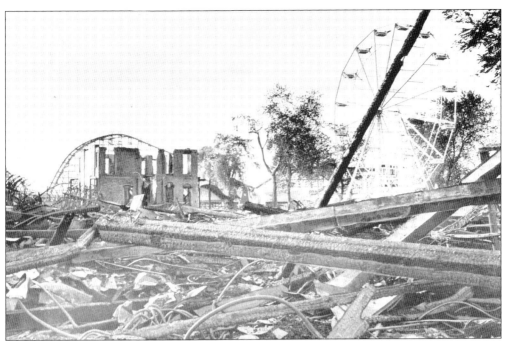

July 19, 1963, the damage is done. All that is left is the Comet and Dodgems in the background and the Ferris wheel to the right. The remains of the Flying Turns/Bobsleds are directly in front of the arcade building. Three years later, all traces of Forest Park Highlands would be erased. The Comet was the last structure to come down. An old era goes and a new era begins.

Mary from St. Louis recollects, "I was born and raised in South St. Louis. I was 11 when the park burned. I watched it from afar at the corner of Kings Highway and Gibson Avenue. I cried, especially when I found out the park would not be rebuilt. However, I did attend Forest Park College, graduating in 1981. Many was the time I thought back about the park as I roamed the halls of the school."

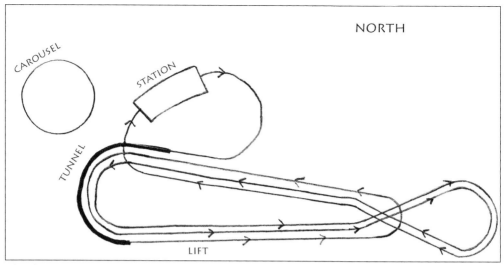

The diagram above shows a different Comet layout. This design was not used at the Highlands. The height on this version would have been 75 feet, and it would have been 3,346 feet long. The tunnel would have been slightly shorter also. The owner thought an up-and-over drop would have been more pleasing to the eye.

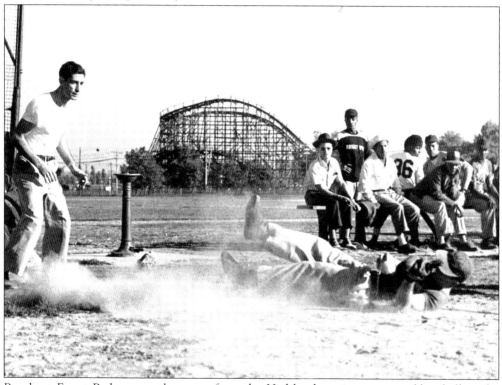

People at Forest Park, across the street from the Highlands, enjoy a game of baseball as the Comet sets forlornly in the background in this 1965 photograph. The Comet would be torn down one year later in February over a period of three days. The scenery has changed drastically since July 19, 1963. (Courtesy of the Western Historical Manuscript Collection, University of Missouri–St. Louis.)

Seven

THE REMOVAL

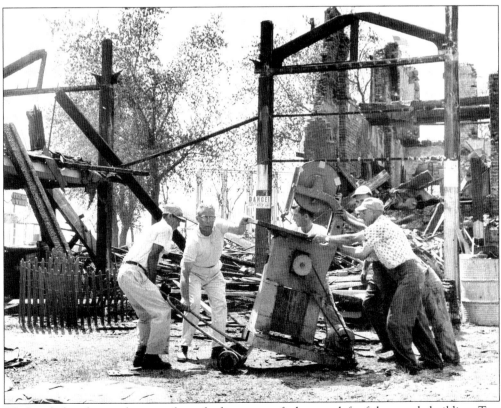

Workers help salvage a buzz saw from the basement of what was left of the arcade building. Two of the rides shown in the background, the Flying Cages and the Tilt-a-Whirl were supposedly bought and moved to Holiday Hill and Chain of Rocks, but Holiday Hill already had a Tilt and neither park had a Flying Cages. So where the two rides actually ended up remains a mystery.

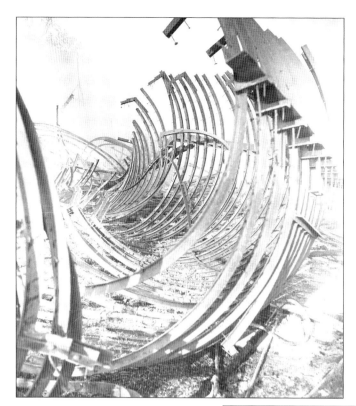

The steel frames for the troughs to the Flying Turns/Bobsleds are all that remains of the most unique ride at the Highlands. This ride was just to the east of the entrance rotunda and was one of the last rides to succumb to the fire. When this ride was destroyed, only three rides of its kind were left in the entire United States.

Jay from St. Louis remembers, "My grandmother's sister was in town with her son, and she and my grandmother were going to take him to the Highlands. It was so hot they thought about taking him the following day; they would've been there the day it burned! My grandfather was driving home on U.S. 40 from Market Street and sat for two and a half hours that day."

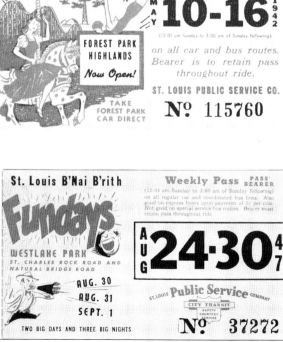

David from St. Louis said, "I never got to go to the Highlands, although I wanted to. I remember Texas Bruce on channel five being interrupted with news of the fire (by John Rodel, I think, and then Chris Condon). I could see the smoke from my grandmother's flat where we lived on Lansdowne Avenue. I remember being so upset (I was seven) that now I would never be able to go there."

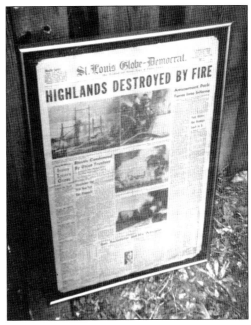

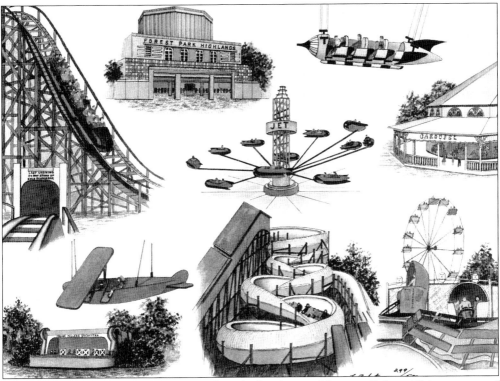

This is a print of an original painting done by local artist Florence Balota. This montage of Forest Park Highlands shows the park's major attractions. From left to right are (first row) the Circle Swings (biplanes version), bandstand, the Flying Turns, the Ferris wheel, and Tilt-a-Whirl; (second row) the Comet, entrance rotunda, Aero-Jets, Circle Swings (the Silver Jet version), and the carousel.

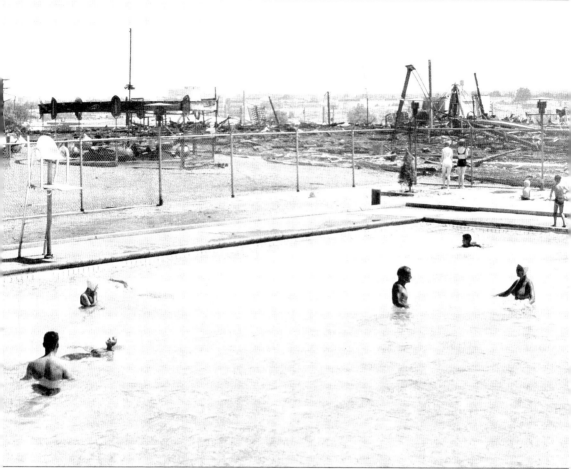

The Sunday after the fire, the park's public swimming pool reopened. This photograph shows a charred Kiddieland, including the remaining cinders of the old fun house building. The metal structure towards the back of the building, directly over the two female swimmers' heads at the fence, was the skeleton of the Bubble Bounce. The swimming pool remained opened for one more season. Two years after the fire, it was discovered that the pool was in worse shape than originally thought. People had decided they did not want to swim in a pool with a burnt-out park surrounding them and the crowds dropped off. The construction of the new community college was going full tilt, so the pool was finally closed. Scorched but still standing in the photograph, but with no colorful canvas cover, is one of the favorite rides for the little people, Budgy the Whale. Soon demolition would begin by the Richard Harder Construction Company to make room for the new college.

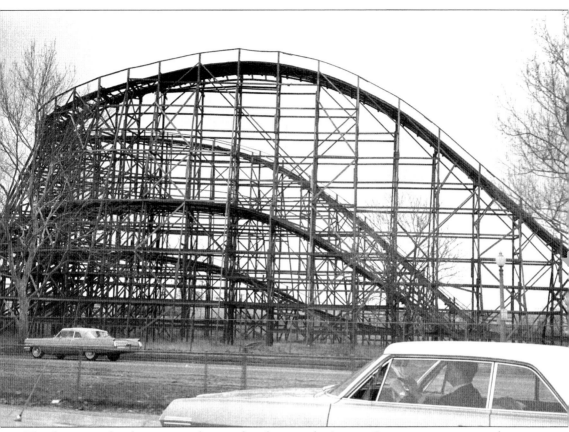

The drivers are heading east in this postfire photograph. A quiet Comet structure sits with an empty station. No more riders. This would be the first swoop turn after the first drop. The track turns to the left and is 60-feet tall at this point. The Comet still gives an imposing effect. There were rumors that the structure was going to be moved to another amusement park, then the rumors changed and it was going to be the mechanical parts that were going to be saved—lift hill chain, brakes, and coaster cars. The structure was finally pulled down over a period of three days in February. Urban legend says that a lead car of the Comet, beat up and rusted out and riddled with bullet holes, was seen in a ditch of the Museum of Transportation in St. Louis. (Courtesy of the Western Historical Manuscript Collection, University of Missouri–St. Louis.)

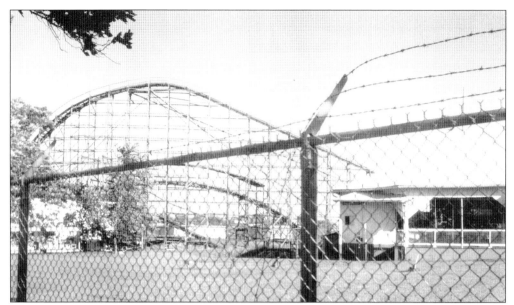

This photograph, taken just after the fire, gives a false since of waiting for the park to open once again. Just outside of the photograph is the charred shell of the old arcade building. Little Toot is parked almost under the Comet's structure, waiting to take riders on a train ride that will not happen again. Not here anyway.

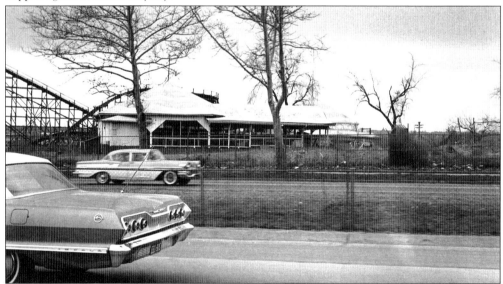

This photograph shows the cars zooming by a once festive, now deserted, amusement park. At this point the only structures left were the Dodgems building, the carousel with its set of stilled steeds, and the Comet. The charred foundation was of the old theater/Hall of Laughter building and the dance hall was all that was left of the entire south side of the Highlands. Most of the large shade trees have already been removed. The Tilt-a-Whirl, Scrambler, and Flying Cages have been sold to a private bidder at auction. The carousel horses and machinery would be removed by a large hole put in the side of the building for that purpose. After that, the Dodgem cars would be removed and sold. The Comet would then come down, the station first. (Courtesy of the Western Historical Manuscript Collection, University of Missouri–St. Louis.)

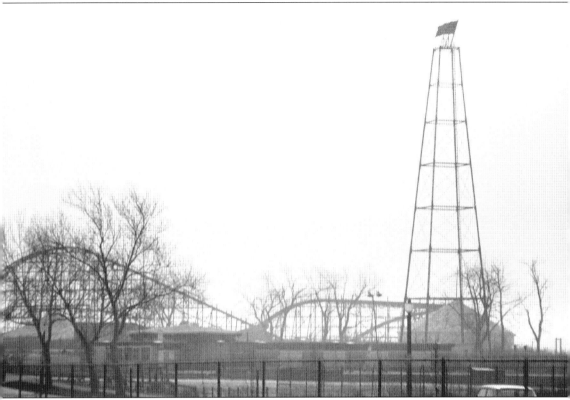

In the foreground of the photograph stands the steel tower with its oscillating flag, never to be lit up again. In all of the flags existence, there were only 48 lights on it. The icon had never been brought up to date. Now there was no need. In the background stands the Comet. The once majestic and colorful cars are now setting in the weeds, the headlight having been busted out by vandals. The bright purple of the coaster cars has faded into a pale, dead lavender. The red seats have not weathered so well left out exposed to the elements. The carousel is boarded up tight to prevent vandals from trying to steel the carousel horses. There is no park between the tower and the Comet. Of these three, the tower came down first.

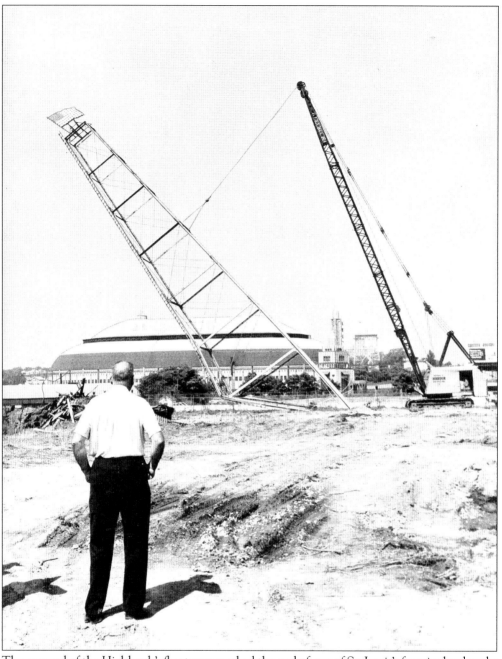

The removal of the Highlands's flag tower marked the end of one of St. Louis's favorite landmarks and the start of the final removal of the Highlands, although it was not the final structure to come down. A year later the flag was offered for sale for the price of $100. There were no takers.

Eight

A FINAL GOODBYE
AND HELLO AGAIN

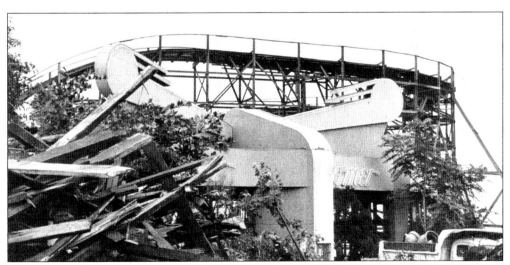

The Comet's deserted structure and empty station lay in wait for their turn with the demolition crew. The Dodgems building is in a heap of broken lumber. Soon all that would be left of the Highlands were souvenirs, memories, old photographs, and a few rides waiting for a new home at another amusement park.

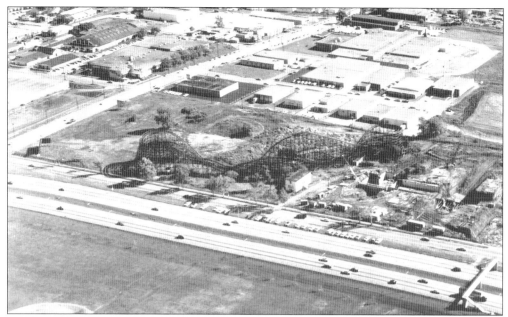

This photograph shows how an old era ends and a new one begins. The Comet's station has been removed, as have all signs of the carousel building to the right and the Dodgems to the left. The only other structure that remains standing is the old Highlands Hotel and the road bed for Little Toot.

Some time ago the Flying Turns occupied this spot along Oakland Avenue. Greenery, lawn, and a walkway for Forest Park Community College now reside here. An option for another name of the community college was Forest Park Highlands. The Highlands was dropped from the name. But next door, at the site of the old St. Louis Arena, a business park complete with a hotel, business offices, and lofts is named the Highlands at Forest Park.

This grove of trees is a nice place to relax while completing ones thesis on defunct amusement parks. Pre-July 19, 1963, it would also be where a person would start the visit to the Highlands at the entrance rotunda. Inside would be four ticket booths and refreshment stands. The floor was terrazzo-tiled, with a large star accented by small circles between each point.

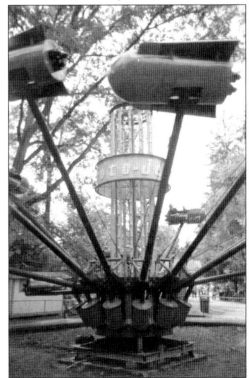

Soon after the fire that destroyed Forest Park Highlands, the surviving rides were sold off at an auction. The Aero-Jets were sold to an up-and-coming theme park in Queens, New York, in 1964. The park was not very successful. It closed a year later. In 1965, Knobles Grove in Elysburg, Pennsylvania, purchased the ride where it still runs today pleasing another generation of riders.

Forest Park Highlands	Forest Park Highlands
ADMIT ONE TO	ADMIT ONE TO
BALCONY POOL	**SPIRAL DIPS**
Compliments	Compliments
Ely Walker Dry Goods Co.	Ely Walker Dry Goods Co.
Good Either (after 6 P. M.)	Good Either (after 6 P. M.)
TUESDAY, AUGUST 30	TUESDAY, AUGUST 30
WEDNESDAY, AUGUST 31	WEDNESDAY, AUGUST 31
FRIDAY, SEPTEMBER 2	FRIDAY, SEPTEMBER 2
President	*President*
NOT GOOD IF DETACHED	NOT GOOD IF DETACHED

Forest Park Highlands	Forest Park Highlands
ADMIT ONE TO	ADMIT ONE TO
BALCONY POOL	**SPIRAL DIPS**
Compliments	Compliments
Ely Walker Dry Goods Co.	Ely Walker Dry Goods Co.
Good Either (after 6 P. M.)	Good Either (after 6 P. M.)
TUESDAY, AUGUST 30	TUESDAY, AUGUST 30
WEDNESDAY, AUGUST 31	WEDNESDAY, AUGUST 31
FRIDAY, SEPTEMBER 2	FRIDAY, SEPTEMBER 2
President	*President*
NOT GOOD IF DETACHED	NOT GOOD IF DETACHED

Rose of St. Louis remembers, "My fondest memory would be the school picnics. It was the day we looked forward to every year. We got a new outfit and made beautiful banners to march in the parade from our school, Gariot, on Hampton and Manchester Avenue. We were poor kids and we would run around to the back exit and around to the front to get at least one more ticket. I spent a lot of time there until the late 1940s as our family lived behind the arena and the Highlands. My mother worked in that restaurant where the fire started when she was a young girl and my sister and I worked at the Photo Gallery for Lida Platz when I was 15 to 17 years old. Ferlin Huskey worked there too on the skee balls and walked me home one night. He was a little to wild for me and I was afraid of him."

The Flying Turns/Bobsleds was one of the Highlands's unique attractions. The ride has not been built since the 1939 New York World's Fair moved their ride to Coney Island after the fair closed. Several companies tried but failed to recreate the Flying Turns's experience. Mach was the only company that came close. As the photographs on this page show, Knobles Grove in Elysburg, Pennsylvania, is recreating the original wood Flying Turns, complete with a three-layer wood trough construction. Designed by John Fetterman, the ride will be 50 feet high, 1,300 feet long, and will make a top speed of 24 miles per hour. The specifications do not sound very impressive, but the Flying Turns did not need a lot of height for a lot of thrill. Engineering is being done by Bill Kelly of Dynamic Design. The ride is expected to be finished by the fall of 2007.

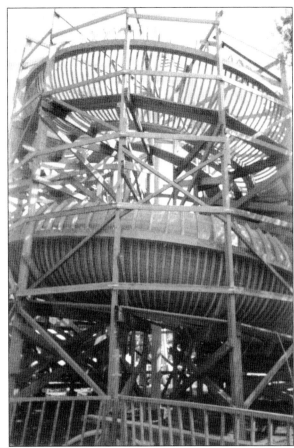

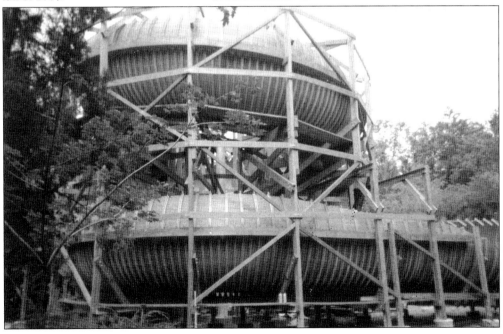

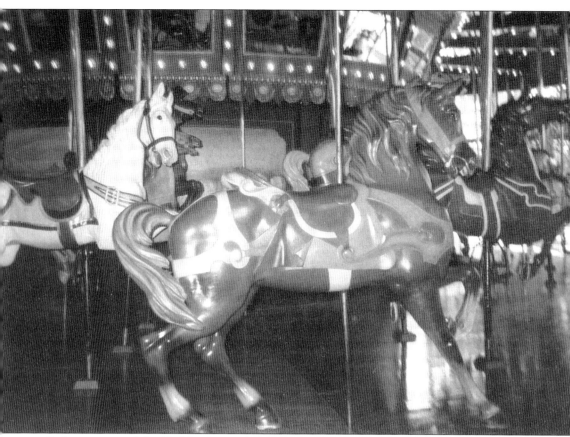

Eighty percent of the Highlands was destroyed by the fire. A St. Louis businessman and a big fan of Forest Park Highlands, Howard C. Ohlendorf, bought the carousel so it would not be split up. After several attempts at restoration, enough money was raised by the St. Louis County Buildings Commission and the Faust Cultural Heritage Foundation. The horses were originally restored by a local Boy Scout troop and eventually the carousel ended up in a climate-controlled building where it still entertains riders today. One of the favorite stories that some children of St. Louis were told is that after the Christmas season was over, four of the reindeer from Santa's sleigh would leave the North Pole and fly to Forest Park Highlands to spend the spring and summer on the carousel. There is now talk of moving the carousel to downtown. (Courtesy of Rose Kennedy.)

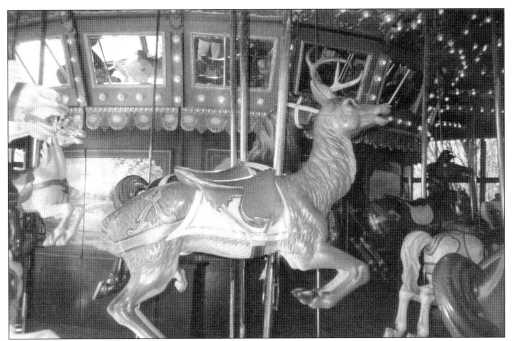

Just three years after the Highlands fire, the old Dentzel carousel was spinning in 52-foot circles once again at Sylvan Springs Park near the Jefferson Barracks. Old age was catching up with the ride, although the horses still arched their necks proudly. Howard C. Ohlendorf, who saved the carousel, arranged to get the horses refurbished, once more taking his role of benefactor seriously. The paint was stripped off, and then the horses were painted a base coat of white. Four of Ohlendorf's daughters and five of their friends were recruited to do the painting. Most of the girls had ridden the carousel at one time or another. Soon the carousel was as good as new and moved to its present location in Chesterfield. (Courtesy of Rose Kennedy.)

Harry of St. Louis remembers "the Highlands the year before it burned down. I was born in 1953. My dad took me on the Bobsled. I remember the sign on the side of the building. I didn't know what the term Bobsled meant and thought we were taking a nice slow aerial tram ride around the park. Dad was a trickster, alright. I remember getting to the top of the hill, feeling the heat of the bright sun, smelling the creosote that permeated the park, then all hell broke loose! I remember it like a black and white video tape. I have never been so terrified in my life—doubt if I ever will be. I remember seeing my mom's face when we got back to the station. She didn't want to ride, didn't want my dad to take me on, and boy, was she furious seeing my green-tinted face! My dad thought it was funny. I was mad. My arms were flailing. I was screaming, but I have to tell you, no other ride has scared me since."

Nine

THE OTHER
AMUSEMENT PARKS

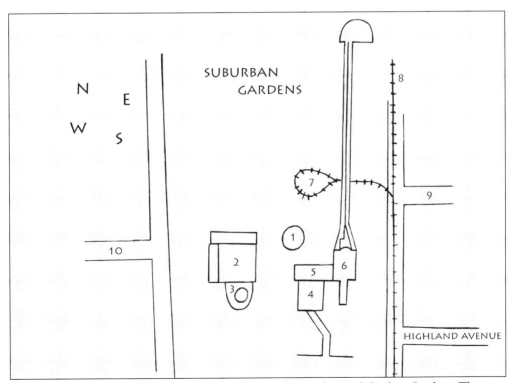

Near the beginning of the 20th century, one of the earliest parks was Suburban Gardens. This map shows its location and a few of its attractions: Circle Swing (1), swimming pool (2), fountain (3), dance hall (4), pavilion (5), scenic railway roller coaster (6), street car loop to the park (7), street car track, later Holdiamont Avenue (8), Kienlen Avenue (9), and Audrey Avenue (10).

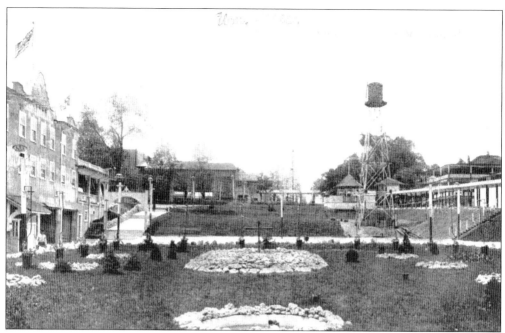

Suburban Gardens was built to guarantee business on the streetcar line. The Suburban Gardens's lifespan was very short compared to the other parks of the day, such as the Highlands or Delmar Gardens. Suburban Gardens was a long rectangle shaped park. The Suburban Scenic Railway ran parallel to the Hodimont Street streetcar right-of-way and formed the east border of the park. Just past Kennerly Avenue was where the streetcar made its loop under the scenic railway to drop off people at the park. Suburban Gardens was short on mechanical attractions, but did possess a scenic railway, carousel, and Circle Swing. The park relied on its many covered pavilions for band recitals, a dance hall, and several ornate fountains to keep the customers satisfied. The park was bordered by Kienlen Avenue on its west side.

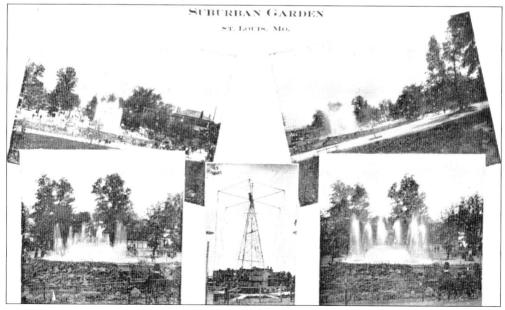

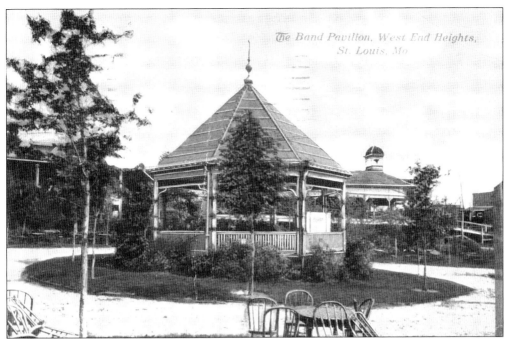

West of Forest Park Highlands, and not more than three miles away, was yet another early amusement park. West End Heights was at the south side of Oakland Avenue at the intersection of McCausland, Clayton, and Oakland. This early amusement park was mainly built to handle the overflow crowds from the 1904 St. Louis World's Fair and the Highlands. The entrance faced Clayton. A carousel, Ferris wheel, and, of course, a scenic railway were among the mechanical attractions. A very large pavilion along Oakland Avenue, containing a restaurant and inside beer garden, was very popular. This early fun land also had an open-air theater and a lagoon that bordered McCausland Avenue. By 1912, most of the remains of West End Heights had been removed.

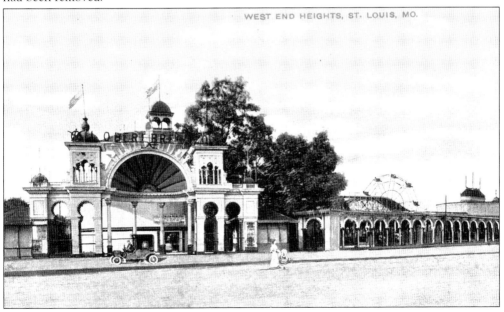

WEST END HEIGHTS, ST. LOUIS, MO.

Delmar Gardens was the prettiest and most complete of the early St. Louis amusement parks. Beautiful buildings with red tiled roofs and multiple columns made this park a step above the rest. It was more successful than most of the early trolley parks, some of which lasted only a few years. Situated on Delmar Avenue, it was just west of the large greyhound racetrack in University City. Delmar Gardens had at least three roller coasters that have been documented, the Figure Eight, a scenic railway, and a later coaster on an elevated structure called the Alpine Roadway, which had cars that looked like the early automobiles. Delmar Gardens also had a moving picture theater, and separate theaters for live entertainment. Soon the land became too valuable, the park was becoming run down, and Delmar Gardens was removed.

The Villa at Beautiful Delmar
ST. LOUIS U. S. A.

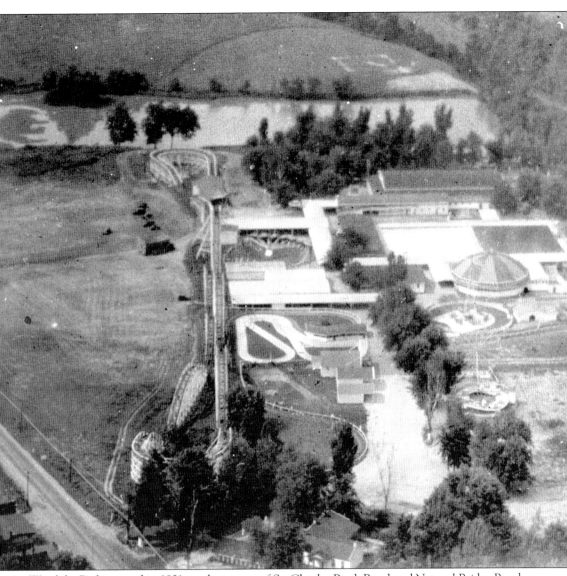

Westlake Park opened in 1921 on the corner of St. Charles Rock Road and Natural Bridge Road. This aerial view shows the park's roller coaster, the Thunderbolt, which made up the park's west border. This park was smaller than the Highlands, but still had the appropriate number of rides including the Thunderbolt, whose specialty was not how high or how long it was, but the number of headaches it caused. Westlake had a slightly more relaxed attitude and reputation than the Highlands. In the late 1940s and early 1950s, there was a minor scandal when it was discovered that Westlake was performing weddings without the benefit of a license. The coaster station is near the top of the photograph. The Tumble Bug is near the first hill. The carousel sits by the park's swimming pool. Westlake had a great fun house and a tunnel of love. By 1956, Westlake Park was a still-fresh memory.

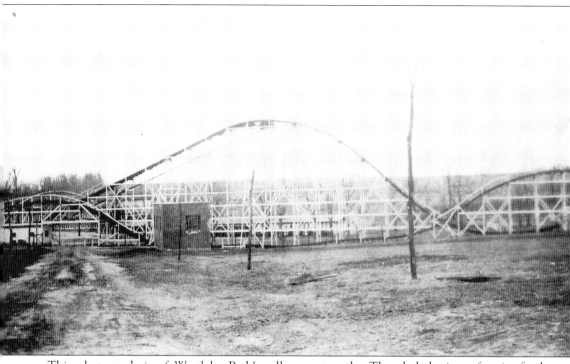

This photograph is of Westlake Park's roller coaster, the Thunderbolt, just after its final construction in 1921. The out-and-back design was built by John Miller who also came up with the idea for under wheels for locking the coaster cars on the track. This feature enabled rides to be built higher and steeper. The Thunderbolt was 65 feet high and 2,800 feet long. The ride formed the west border of the park. At several points in the ride, the dips would either be on the ground or slightly below grade creating a longer drop. The ride was known not only for the ride but the amount of headaches it would give virtually every rider who rode it. The ride was not the highest or the longest, but it could have given another ride competition for being the roughest.

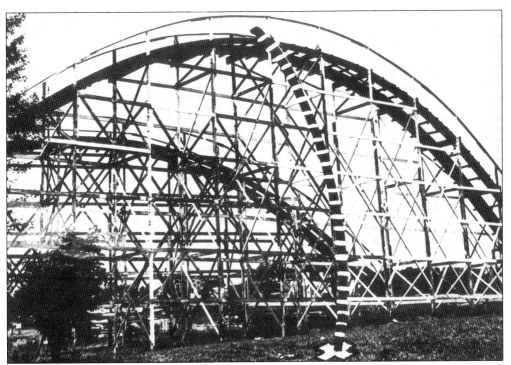

Every amusement park has its share of unsafe riders. Westlake was no exception. One unsafe rider paid the ultimate price. In this crime scene photograph, the investigator has drawn marks showing the pathway the rider took as he was thrown out of the coaster car while trying to stand up. The X marks the spot where the rider's body landed.

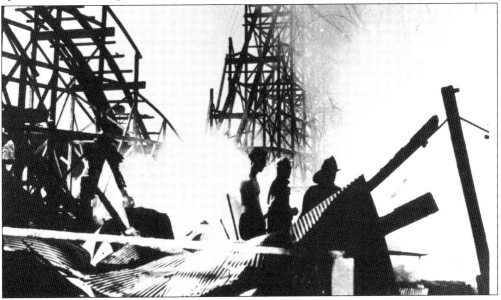

Fire was often the nemesis of amusement parks, which were frequently of wood construction. On May 15, 1955, fire all but destroyed another one of St. Louis's amusement parks. Westlake had fires in the past, but this was the worst one yet. The coaster was very nearly destroyed. The park made a valiant attempt to stay open. It barely made the next season, using the fun house as its major draw.

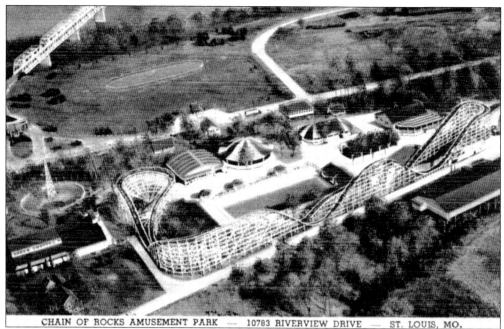

CHAIN OF ROCKS AMUSEMENT PARK — 10783 RIVERVIEW DRIVE — ST. LOUIS, MO.

Chain of Rocks originally got its name from the actual chain of rocks in the Mississippi River that Native Americans would use to cross the river. Its isolation gave this amusement park a secret fairyland appeal. This postcard view shows the entire layout of the park and the park's roller coaster, the Comet.

DINING ROOM and BAR

Amusement parks have plenty of places to eat. Before the days of theme parks, almost every park had a sit-down table service restaurant or dining hall. A lot of the restaurants would even serve mixed drinks later in the evening. The wide selection of choices was a vast improvement over the standard hot dog and hamburger fare.

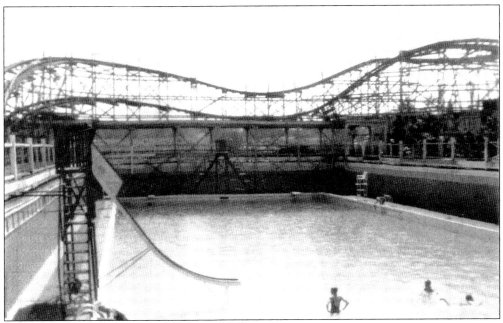

This photograph shows the tail end of a newly constructed Comet roller coaster. This coaster had a unique structure, it was built with a walkway enabling park patrons to get to another section of the park. When the new owners bought out Chain of Rocks, the coaster was in such deplorable condition, they had no choice but to dismantle the ride.

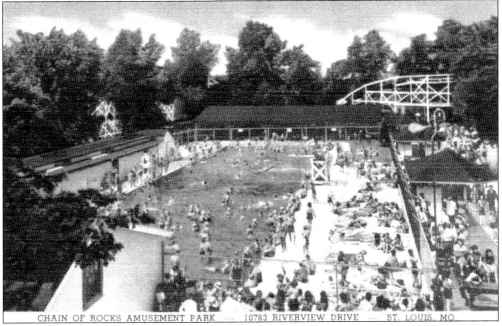

CHAIN OF ROCKS AMUSEMENT PARK — 10783 RIVERVIEW DRIVE — ST. LOUIS, MO.

Chain of Rocks, like any good amusement park, had a public swimming pool. The pool in this postcard view shows the park's roller coaster bordering it on two sides. The pool survived until the park's closing in the late 1970s. A gruesome urban legend tells of a rider meeting his demise after being catapulted into the swimming pool while trying to stand up on the fast-moving coaster.

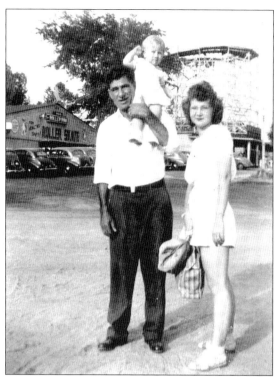

This happy family prepares to have a festive day under the many trees at Chain of Rocks. The park's Comet and roller skating rink are in the background. The Chain of Rocks skating rink was one of the most popular places to skate in St. Louis.

FUNLAND OVERLOOKING THE MISSISSIPPI

CHAIN OF ROCKS PARK
ST. LOUIS, MO.

Dudley of St. Louis remembers, "Every time we would head towards Missouri on the old Chain of Rocks bridge, I would start to stretch my neck to see when I could spot the first signs of the amusement park on the bluff. Usually the first thing I would see was the tower to the park's Circle Swing, then the first hill of the Comet, the parks roller coaster. That's when I would start to get a little bit too excited."

A mother and daughter pose in front of their family car with the hills of the Chain of Rocks's Comet in the background. Amusement parks were great places to mend those mother-daughter feuds that rise up from time to time. The Comet was set back from the bluff's drop. It was considered an L-shaped, out-and-back coaster.

Sue and Duke Garner of St. Louis remember, "We would always take our son to the park because we knew he loved those places so very much. His dad would tease him, because almost every time our son would see a steel structure of some kind, his father would swear up and down that it was a new ride under construction to be moved to Chain of Rocks later."

Skate your Date at...

"CHICAGO"

IDEAL ROLLER RINK
AT
CHAIN OF ROCKS PARK
ST. LOUIS; MO.

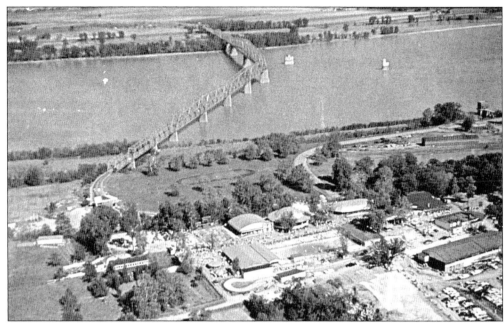

Chain of Rocks soon changed its name to Chain of Rocks Fun Fair Park. In an attempt to modernize the park, Ken Thone, the general manager, had several new carnival rides put in. A Wild Mouse, go-cart tracks where the Comet once stood, and even a double Ferris wheel gave the park a new look. Arson struck one year, and the park's beloved carousel was destroyed.

Betty of St. Louis remembers, "I took my little brother on a ride at Chain of Rocks I just remember as sliver tubs. As they rotated, you could spin your individual tub. I spun ours so fast, as soon as my little brother crawled out of the tub after the ride stopped, he was so dizzy, he couldn't stand up. I was reminded of that a few years ago as we were watching the television and that commercial came on with the elderly lady saying 'I've fallen and I can't get up.'"

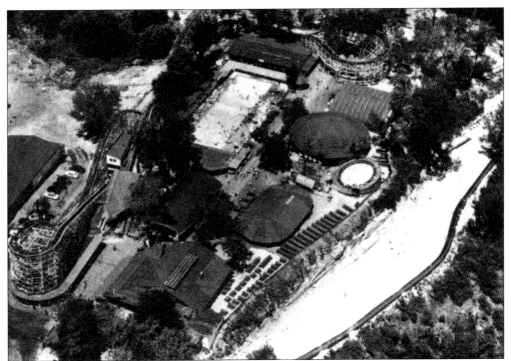

This aerial view of Chain of Rocks shows the entire park, including the Comet's L-shaped layout. The park's unique ride was the Swooper, which is shown next to the carousel building. The oblong roof is the park's Whip ride. The Moon Rocket is the circle next to the carousel. The park's Circle Swing tower is just out view of the top of the photograph.

A cheap souvenir pennant from Chain of Rocks cost maybe 75¢. Admission to that park would have been free except towards the end of its life span when the thing to do was charge an admission fee to get into the park and then later a fee just to park the car. The memories that last forever are priceless.

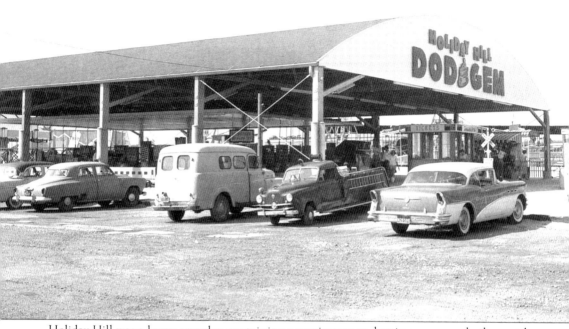

Holiday Hill was a larger complex containing a putting range, batting cages, and other outdoor entertainment, located on the corner of Natural Bride and Brown Roads just inside of Berkley, the St. Louis airport. The complex was cut back when Route 70 was built. Only the kiddie park and public swimming pool remained.

The amusement section was made up of several child-sized rides. A Ben Schriff kiddie coaster was on the west side of the park. The park also had a 45-foot Ferris wheel, a Roll-o-Plane, and an Octopus for the adults to ride. There was a Dodgem ride and also a small miniature railroad that surrounded the pint sized park.

Daniel of St. Louis recollects, "When I was in day camp in the 1950s, quite often we would take a trip to the Holiday Hill swimming pool. It was separated by the park's train tracks. Every time we would go swimming, I always was wishing I could be in the park enjoying the rides. One day, I jumped off of the side of the pool into my inner tube. I went straight through, coming up splashing and coughing up a storm. I had missed my little tube. Mom was watching us from behind the fence, having a real fit, but by the time she and the life-guard got to the side of the pool, I had found my inner tube and all was well. After that no one ever pressured me to go swimming again. As for me, many years later, I ended up joining the navy. Fortunately, I did not fall off of any ships or pools."

A kiddie park was not complete without a fun house. A terrifying walk through the spook house, complete with a tilted room and another room with a mushy floor, scared many youngsters, who were mostly frightened by the tall tales the older brothers and sister were telling them. The park also had an Octopus ride along with a children's favorite, tanks on a wood-track bed. At the other side of the park were live Shetland ponies future cowboys and cowgirls could ride.

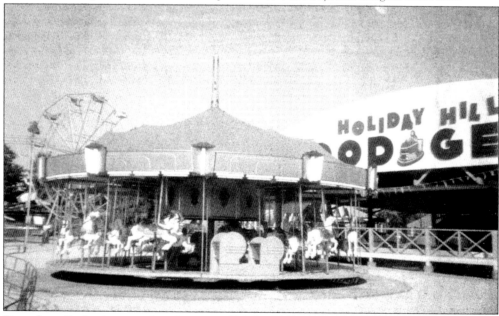

Doug from St. Louis remembers "going to Holiday Hill one day and it was pouring rain. You could barely see the park. My dad and I sat and sat and sat. The rain did not let up. We sat there for one hour, me crying my eyes out until my dad, finally giving up on the rain, drove home."

Forest Park Highlands
ADMIT ONE TO
MYSTERIOUS HOUSE

Compliments
Ely Walker Dry Goods Co.
Good Either (after 6 P. M.)
TUESDAY, AUGUST 30
WEDNESDAY, AUGUST 31
FRIDAY, SEPTEMBER 2

President

NOT GOOD IF DETACHED

Forest Park Highlands
ADMIT ONE TO
MYSTERIOUS HOUSE

Compliments
Ely Walker Dry Goods Co.
Good Either (after 6 P. M.)
TUESDAY, AUGUST 30
WEDNESDAY, AUGUST 31
FRIDAY, SEPTEMBER 2

President

NOT GOOD IF DETACHED

LAST BIG WEEK!
FOREST PARK HIGHLANDS
COMPLIMENTS OF
ELY WALKER DRY GOODS CO.
TO THEIR EMPLOYEES
GOOD ON EITHER
TUESDAY, AUGUST 30
WEDNESDAY, AUGUST 31
FRIDAY, SEPTEMBER 2
GOOD ONLY AFTER 6 P. M.
NOTE — This book is for a party of TWO
Not good for children under 16
IN THE PAGODA
Kenneth McKinnon
Child Wonder Xylophonist
And OTHER FEATURE ACTS
LAST BIG WEEK !

Forest Park Highlands
ADMIT ONE TO
RACING DERBY

Compliments
Western Cartridge Co.
Good Either (After 6 P. M.)
MONDAY, JULY 15
TUESDAY, JULY 16
FRIDAY, JULY 19

President

NOT GOOD IF DETACHED

Forest Park Highlands
ADMIT ONE TO
RACING DERBY

Compliments
Western Cartridge Co.
Good Either (After 6 P. M.)
MONDAY, JULY 15
TUESDAY, JULY 16
FRIDAY, JULY 19

President

NOT GOOD IF DETACHED

Dan from St. Louis remembers, "I had fallen out of a tree as a child. Haven't we all? I was promised a trip to Holiday Hill for my birthday. I was in a full leg cast from the tree fall. Then, the safety regulations were not as strict so I got to ride. Riding the Roll-o-Planes, we were tossed one way then the next. The three of us were all in one car. My poor sister kept yelling 'Mother! Mother!' She was scared out of her wits. We were pummeled with every thing my mom had in her pockets. She was not amused when we returned home, her arms covered in bruises from trying to hold me in that ride. She kept her promise to me though. I was taken there for my birthday, cast or no cast."

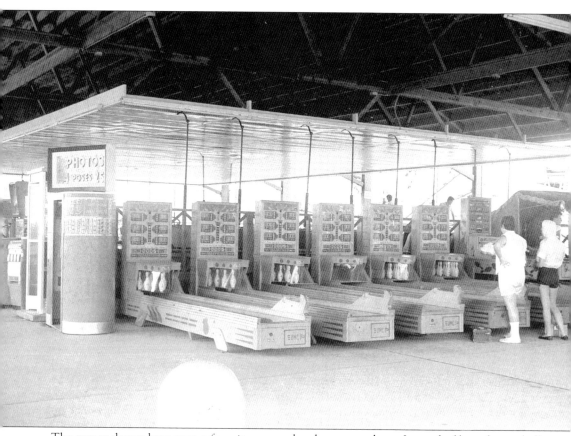

The games shown here were a favorite among bowlers everywhere. Instead of large heavy balls to toss around, they were replaced by small round flat steel pucks. The object of the game was the same, to try to knock down as many pins as possible. The person playing the game would slide the pucks down the alley, as it were. When the pucks would get to where the pins were, the pins would pop up into the mechanics of the game. The buildings these games were in were more of a picnic shelter type than a substantial arcade like the Highlands. It would often share the building with a set of bumper cars and maybe a hamburger stand off to one side. These games were also very popular in various taverns and bars, but Holiday Hill was a much more pleasant surrounding.

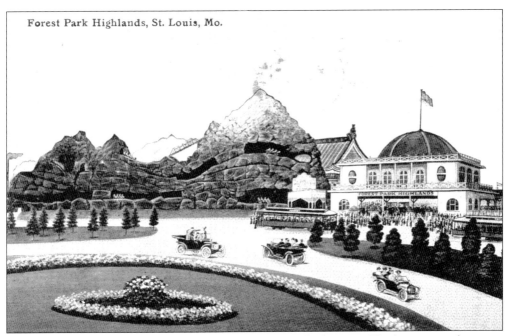

Forest Park Highlands, St. Louis, Mo.

The top photograph shows a very different scene than the bottom. The location is the same. One was in 1912; the other was in the 1980s. Places like these come and go way too quickly. Some amusement parks lasted only five years or even less. There was an instance in Detroit where a roller coaster was taken down because a small piece of land the ride was setting on was not owned by the park. Amusement parks can have a very long life. Lake Compounce in Connecticut has lasted a century. The people of St. Louis were lucky to have several amusement parks lasting from the early 1900s to the late 1970s.

ACROSS AMERICA, PEOPLE ARE DISCOVERING SOMETHING WONDERFUL. THEIR HERITAGE.

Arcadia Publishing is the leading local history publisher in the United States. With more than 3,000 titles in print and hundreds of new titles released every year, Arcadia has extensive specialized experience chronicling the history of communities and celebrating America's hidden stories, bringing to life the people, places, and events from the past. To discover the history of other communities across the nation, please visit:

www.arcadiapublishing.com

Customized search tools allow you to find regional history books about the town where you grew up, the cities where your friends and family live, the town where your parents met, or even that retirement spot you've been dreaming about.